POSTCARD HISTORY SERIES

Sister Lakes

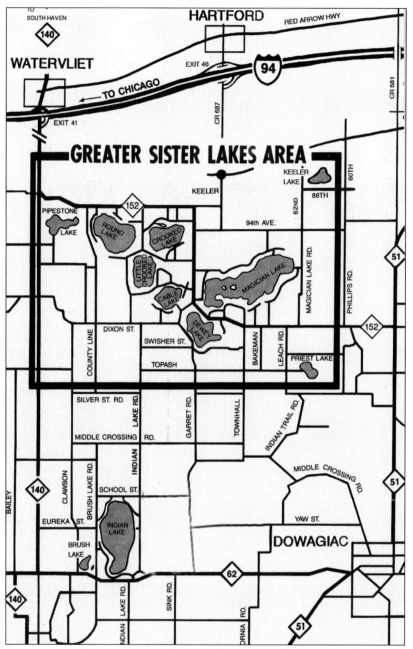

This map shows the lakes and surrounding area known as Sister Lakes. (Courtesy of Jerdon Real Estate.)

On the front cover: Please see page 50. (Courtesy of Floyd Jerdon.)

On the back cover: A typical postcard of the 1910 era is shown in this image. This represents a local photographer's collage of pictures of the Sister Lakes. Each scene in these photographs was also available on postcards to the public. (Courtesy of Floyd Jerdon.)

POSTCARD HISTORY SERIES

Sister Lakes

R. L. Rasmussen

ARCADIA
PUBLISHING

Published by Arcadia Publishing
Charleston SC, Chicago IL, Portsmouth NH, San Francisco CA

Printed in the United States of America

Library of Congress Catalog Card Number: 2007920837

For all general information contact Arcadia Publishing at:
Telephone 843-853-2070
Fax 843-853-0044
E-mail sales@arcadiapublishing.com
For customer service and orders:
Toll-Free 1-888-313-2665

Visit us on the Internet at www.arcadiapublishing.com

*To the generations of people who have made
Sister Lakes a part of their lives*

CONTENTS

ACKNOWLEDGMENTS

We often hear the phrase "I couldn't have done it without him." Well, for this book, it truly is the case in regard to Floyd Jerdon from Dowagiac. Because of his real estate company's involvement with properties on the Sister Lakes, he has always had a special interest in the area. Over the years, he has put together a huge collection of old postcards about these lakes. Floyd and I met about 14 years ago at postcard shows and have finally decided to pool our talents and postcards to produce this book.

Part of the fun and joy of making one of these books is the people you meet and the stories you hear. Floyd and I would like to thank and acknowledge these people and institutions in the following alphabetical order: Cass District Library, local historical branch; Coloma Public Library; Dowagiac Public Library; Maple Island Historical Committee; Maude Preston Palenske Memorial Library; Montgomery's Restaurant Coffee Crew; Southwestern Michigan Museum; Van Buren District Library, Decatur branch; Delores Ardith; Don G. Blackmond; Connie Timmons Canfield; John D. Cooper; Patrick Daly; Barb Fisher; Rocky Gulliver; Robert Hall; Jerry Hannapel; Jack Hartsell; Thomas Jerdon; Ed Miller; Randy Moore; Beverly Nemeth; Bruce Nevins; Phillip Nevins; Tim Pitcher; Harold Schaus; Bill Schueneman; Suellen Schueneman Siglow; Michael Smallbone; John Steimle; Susan Wagner; Jason Wesaw, Pokagon Band of Potawatomi Indians; and Evelyn Coates Wise.

A special thanks to Barbara Calloway for helping put this book together.

To learn more, readers may visit the following Web sites: www.swmichiganstore.com and www.jerdon.net.

INTRODUCTION

Why don't you come visit us this summer at our cottage? For over the last 125 years, to be able to offer that invitation has been one of the American dreams. The ability to have a house or cottage as a second home has been, and still is, a goal for many families. One of the places to fulfill that dream in the Midwest, and particularly the Chicago area, has been the Sister Lakes in southwest Michigan. Its proximity to the Chicago metropolitan area, the many forms of transportation, and the variety of accommodations through the years have made it a summer playground and destination for generations.

Technically the two lakes that are called Sister Lakes are Round Lake and Crooked Lake. By 1877, there were enough people in the region for the United States government to open a post office. Since it was located between the two lakes, it was named Sister Lakes. Geographically this book encompasses the other nine lakes within a six-mile radius as well. The lakes are as follows by size: Magician Lake, which is 520 acres and has three islands in it, named Maple, Scouts, and Hemlock; Indian Lake, which has 500 acres; Dewey Lake with 223 acres; Round Lake with 194 acres; Big Crooked Lake with 110 acres; Little Crooked Lake with 103 acres; Cable Lake with 91 acres; and the four smaller lakes of Keeler, Pipestone, Priest, and Brush.

These 11 lakes are in the corner of three different counties and three different townships in southwest Michigan, those being the counties of Cass, Berrien, and Van Buren. The townships are Bainbridge, Keeler, and Silver Creek. All of these are mentioned because each plays a part in the history and development of the Sister Lakes area. Each lake and the land around it has its own personality and lifestyle. Questions come to mind such as, was the property sold or only leased? Where did that resort advertise for its vacationers? Which ethnic group or Chicago neighborhood came to that particular lake? What other local communities were drawn to that particular lake? All of these factors gave each lake and resort a unique character. When we add the surrounding villages and cities influenced by these lakes, the history and images just become richer and more detailed.

Southwest Michigan, with its lakes, land, and people, is a microcosm of this country's development. The area's settlement literally goes back at least 2,000 years. The Hopewellian Indian Mound Builders seem to have been the first inhabitants of the area. By the time the French explorers and Catholic priests came in the 1670s, the Native Americans living here were of the Potawatomi tribe. The settlers of the 1830s who came from the eastern states via the Erie Canal became prosperous farmers over the next 100 years. The geography and weather of this region made fruit one of the most important and successful crops. The villages became cities with industry and a network of roads and railroads supplying materials and people to the area. The numerous lakes of the region were an added benefit just waiting to be enjoyed. By the 1880s, families were starting to have enough money to take vacations. The Sister Lakes area

had become one of the places for that vacation. Farms became resorts, and lake frontage turned into valuable lots for cottages. This section of southwest Michigan quickly became a summer destination and continues to be a mecca for vacationers. The sheer number of individuals and families over the last 125 years is amazing. Each person and family has memories, traditions, and stories to tell about their stay at the lakes. Hopefully the postcards in this book will bring back some of those experiences. Also for the newcomer to these lakes, these photographs will provide a greater appreciation of its history.

Because of the format of this series, I can only touch the surface of the rich history and colorful people who made it such a wonderful place to visit. Fortunately the area has Floyd Jerdon. His family's roots to the area, 50 years plus of selling local real estate, a commitment to the area history, and a legendary collection of old postcards make this book a reality.

One

NATIVE AMERICANS

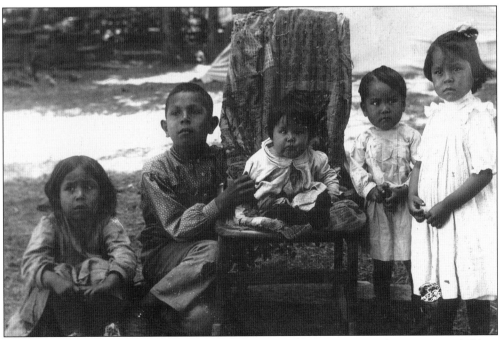

This rare 1908 photograph taken at Sandy Beach Resort shows a group of Potawatomi children during the time the band was staying at this location. Notice the young boy hanging on to his sister in the chair set up for this photograph and the variety of expressions on the children's faces. A local photographer then made it into a postcard to sell to early vacationers. These are now valuable because so few were made of the Sister Lakes Potawatomi band of Native Americans.

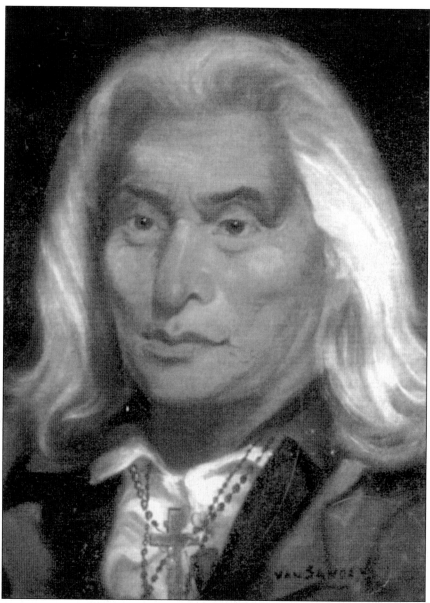

This portrait of Leopold Pokagon was painted by the artist Van Sanden. Pokagon was chief of the Pokagon Band of Potawatomi Indians living in the Sister Lake area in the 1830s. During the negotiations of the 1833 Treaty of Chicago, Chief Pokagon very eloquently and forcefully spoke for his people. Subsequently his demands were added to the treaty and his band was exempted from removal from its native lands. In 1840, Brig. Gen. Hugh Brady, commanding the United States Army units in Detroit, was ordered to remove all Potawatomi Indians from Michigan and Indiana. On hearing this news, Chief Pokagon traveled to Detroit, where he presented his people's case. Judge Epaphroditus Ranson of the Michigan Supreme Court issued his legal opinion in favor of the Native Americans. Taking this document with him on August 17, 1840, Chief Pokagon met with Brigadier General Brady near Silver Creek. At that time, General Brady wrote out a pass guaranteeing the Potawatomi the right to live in Michigan "unmolested." (Courtesy of Northern Indiana Historical Society.)

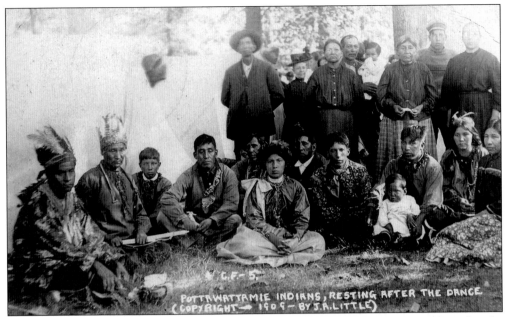

This 1909 photograph made into a postcard is titled "Pottawattamie Indians, Resting after the Dance." Because these Native American photographs were so exceptional, the photographer, J. R. Little, even had this one copyrighted. This postcard demonstrates how the Potawatomi adapted their clothing according to their needs and lifestyles. Here is a group of Native Americans in native dress for their dancing ceremony and other tribal members in American clothing.

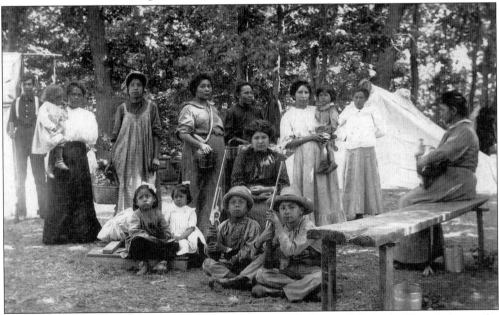

By the early 20th century, a large group of Potawatomi had moved from the Sister Lakes to the Hartford area around Rush Lake. Following their traditions, they would come back for special occasions. This 1910 group of Potawatomi was encamped along the southern side of Dewey Lake. The group had come to this site next to Sandy Beach Resort for the yearly picking and harvesting of huckleberries.

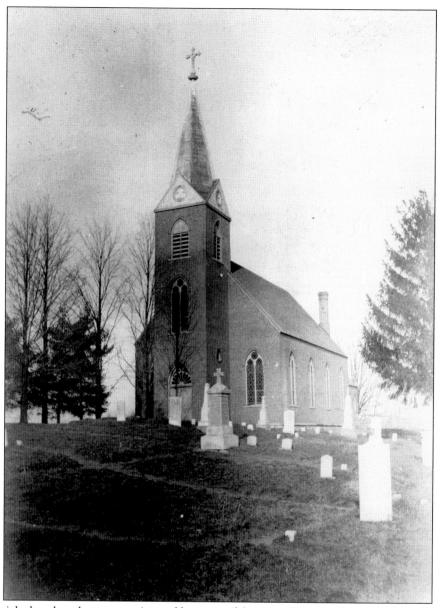

The brick church and cemetery pictured here are of the Sacred Heart of Mary Catholic Church. This building is located off M-152 in Silver Creek Township. Its history and connection to the Pokagon Band of Potawatomi is significant. By 1830, Chief Leopold Pokagon and his people had converted to the Catholic religion. The chief assigned 40 acres of the 874 acres he owned for the use of a chapel and school by the "black robes," who were Catholic priests. The current church sits on the site of the original log church. The combination of being Christians, farmers, and owning land around this church saved the Pokagon Band from being exiled to Kansas in the 1840s. When Chief Pokagon died in 1841, his grave was placed under what is now the right corner of the present-day brick church. One of his sons, Simon, attended Notre Dame University and became an author and spokesman for his people on a national level. During the World's Columbian Exposition of 1893 (commonly known as the world's fair) in Chicago, Simon was asked to speak at one of the ceremonies.

Two

THE FIRST RESORT

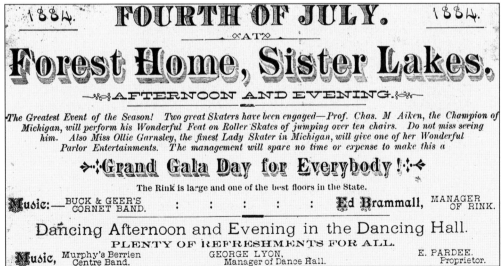

This 1884 double-sided card is an advertisement for the Fourth of July celebration at the Forest Home Resort. This property was originally a camping site for local businessmen since the 1860s. An example of this was Elias Pardee and A. Maykes staying there in a nine-foot-square tent. In 1876, Pardee bought the property from B. D. Sill for $100 per acre and turned it into a resort.

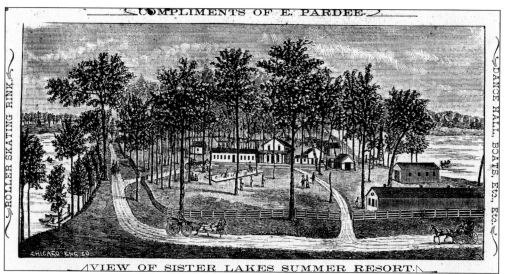

ROLLER SKATING RINK

DANCE HALL, BOATS, Etc., Etc.

CHICAGO ENG CO.

VIEW OF SISTER LAKES SUMMER RESORT.

The opposite side of the 1884 card shows a drawing of what the buildings and lakes looked like when this resort was first built. The resort was located on a narrow strip of land only 412 feet wide. Shown are a number of buildings that included a roller rink, a dance hall, and a pool hall. The resort also offered a special children's play area.

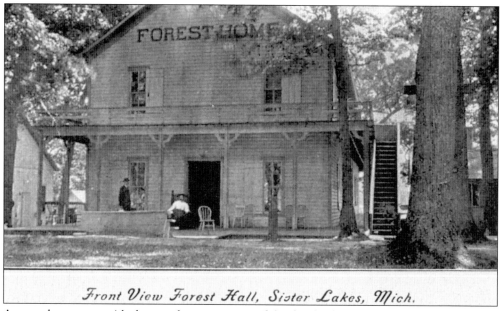

Front View Forest Hall, Sister Lakes, Mich.

As was the custom with these early resorts, one of the first buildings to be erected was a large multipurpose hall. One of the earliest photographs of this resort is of the front view of this building, which was named Forest Hall. These buildings would typically have a front porch where vacationers would relax and socialize.

14

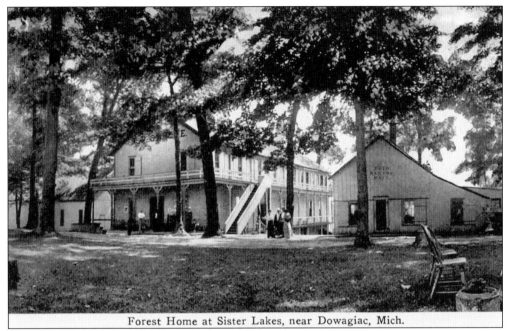

Forest Home at Sister Lakes, near Dowagiac, Mich.

On the right side of the large Forest Hall building stands the dining hall. Each building had its named painted on it. The dining hall has the date of 1876 above the words *dining hall*. Notice the wooden chairs on the lawn that are on the right-hand side of the postcard. With the summer heat and the type of clothing worn during this period, people would congregate outdoors in small groups.

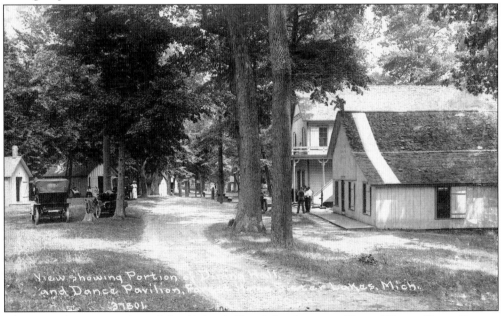

This view shows a portion of the dining hall and the dance pavilion of Forest Home Resort. These two buildings were the hub of all activities at the resort. The road here separates some of the cottages from the rest of the complex. The number of the postcard, 37801, will be explained later.

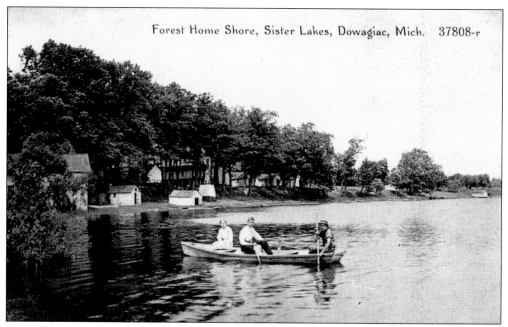

Forest Home Shore, Sister Lakes, Dowagiac, Mich. 37808-r

One of the customs was to have a photograph taken enjoying an activity at the resort. This was usually taken from another boat. These vacationers in a rowboat were posed so that they may have their picture taken for this card, which would then be sent back home. In the background are some of the buildings that made up the Forest Home Resort.

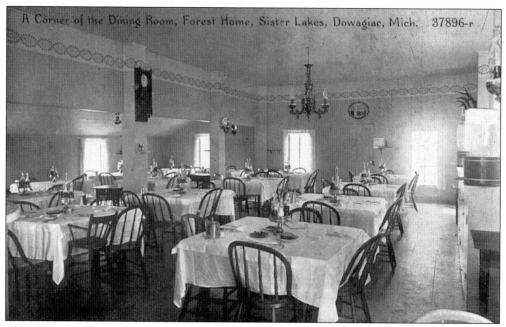

A Corner of the Dining Room, Forest Home, Sister Lakes, Dowagiac, Mich. 37896-r

This picture shows the inside of the dining hall at Forest Home Resort. Guests would have all three of their meals in this room. Due to the large number of vacationers, they would be served at different times. The kerosene lamps hanging from the ceiling and on the walls were their only means of light.

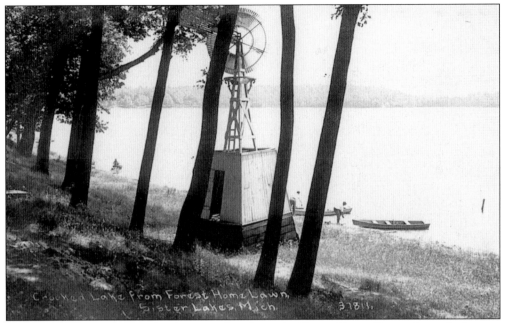

This view of Little Crooked Lake was taken from the Forest Home Resort lawn. It shows a windmill, which served as one of the sources of water for the resort. Beneath the windmill is a holding tank for the water. The windmill's function was to fill this tank so water would always be available.

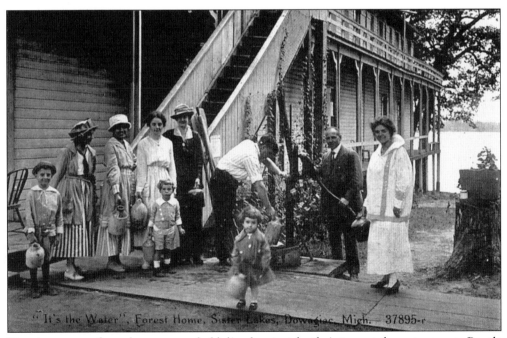

Here is a group of people, young and old, lined up to take their turn at the water pump. People would bring a jug from their tent or cottage to fill and take back for personal hygiene or drinking water. These newly arrived guests were given a water jug with their room key.

Visitors at Forest Home,
Sister Lakes,
Dowagiac, Mich. 37863

Another feature of the Forest Home Resort was a photographer who was always available for group pictures. Even at the beginning of the 20th century, visitors and relatives felt they could drop by or stay with the vacationers. In this postcard, several generations have arrived and posed for this happy family photograph.

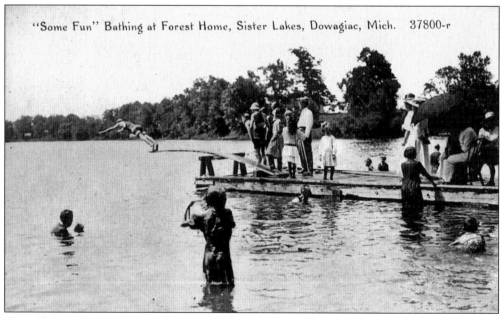

"Some Fun" Bathing at Forest Home, Sister Lakes, Dowagiac, Mich. 37800-r

One of the main reasons people came to the lakes was to enjoy the water, especially if they were from a city. In these early postcards, the term *swimming* was never used. Instead everyone always went *bathing*. This scene shows a very basic diving board with a bather in the process of diving.

Three

BIG CROOKED, LITTLE CROOKED, AND ROUND LAKES

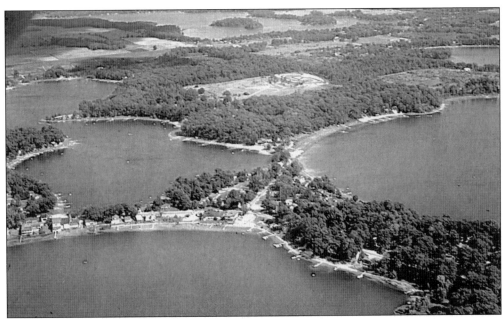

This is a 1960s aerial photograph of the Sister Lakes area. The view is looking east showing sections of five lakes. At the bottom of the postcard is Round Lake. The lake on the left side is Big Crooked, and the lake on the right side is Little Crooked. In the background is Magician Lake, and on the right side is a small part of Cable Lake. (Courtesy of Penrod-Hiawatha Company.)

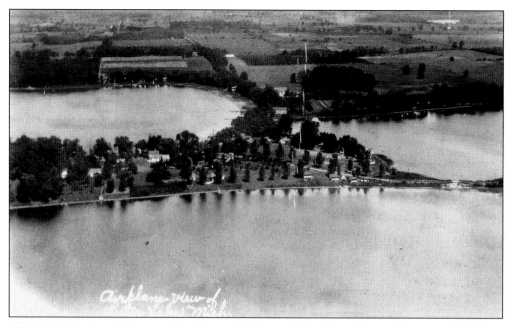

This 1927 photograph is one of the first aerial views of the Sister Lakes. The view of the three lakes is from a northeastern angle. The lake at the bottom of the postcard is Little Crooked. The lake on the left side is Round Lake, and the right side shows Big Crooked Lake. Notice the channel between Big and Little Crooked Lakes on the right middle side.

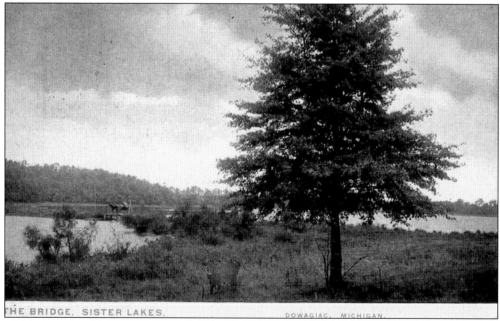

THE BRIDGE, SISTER LAKES. DOWAGIAC, MICHIGAN.

This 1916 postcard just calls this scene "The Bridge, Sister Lakes, Dowagiac, Michigan." What is important is that the two lakes, Big Crooked and Little Crooked, seen in the picture are really, in fact, one lake. In the past, they were connected by a shallow area of marshes. As the postcard shows, there is a primitive bridge connecting the two land masses. A horse and buggy are crossing it at that time.

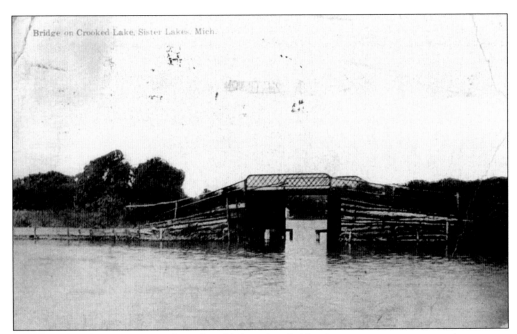

Because of the heavy amount of travel at this location, bridge improvements were very important. This view of the bridge shows how areas have been filled in on both sides to raise the bridge. The original pilings for the first bridge can be seen under the newer bridge. The retaining walls leading up to the new bridge were made of logs.

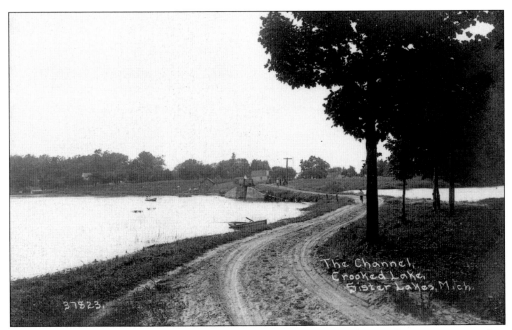

This photograph shows the original dirt road leading up to and over the water connection between Big and Little Crooked Lakes. In this postcard, it is now being called "the channel." The angle of the picture gives an idea of the large amount of fill dirt, which had to be used to make this connection.

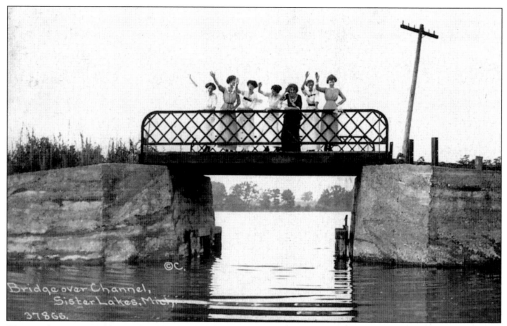

Shown here is a group of young ladies waving to the photographer, who is in a rowboat for this picture. By the time this photograph was taken, the retaining walls had been rebuilt with concrete, and a metal railing had been put in. The bridge was raised to this height so that boats could travel between the two lakes.

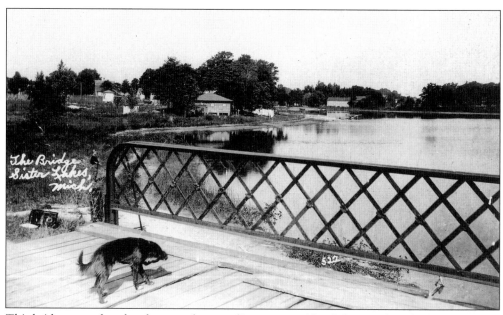

This bridge scene has the photographer standing on one side of the wooden planked structure. His intention was to get a view of the lake, cottages along the shore, and laundry hanging out on a summer day at Sister Lakes. What is included is the photographer's extra camera lying on the left side in the grass and his dog, who decided to wander into the picture.

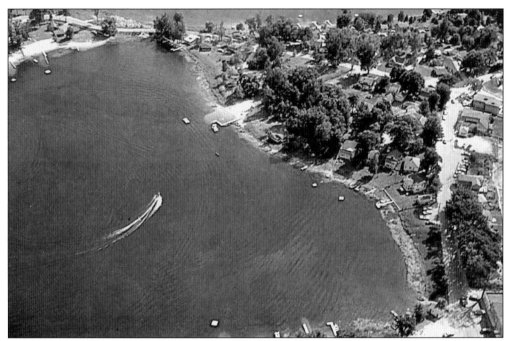

This postcard is a 1965 aerial view of Big Crooked Lake (foreground) and Little Crooked Lake (top). The area in the upper left side is where the bridge used to be located. Instead of a channel between the two lakes, there is now a culvert under the road that connects the two lakes. The buildings on the far right are some of the businesses facing Round Lake. (Courtesy of Penrod-Hiawatha Company.)

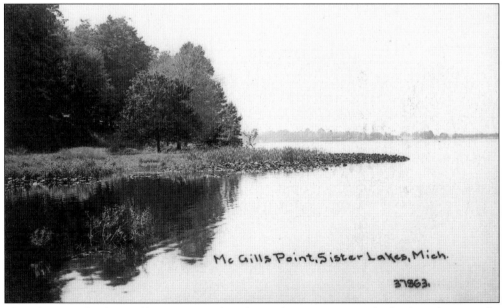

This photograph of McGills Point was taken from a boat on Big Crooked Lake. The name for this point probably was for an early settler who owned the property. This is one of the points that forms what is known as the Narrows. Because of this narrowing, on a busy summer weekend, boats have to slow down to pass one another and enter the two sections of Big Crooked Lake.

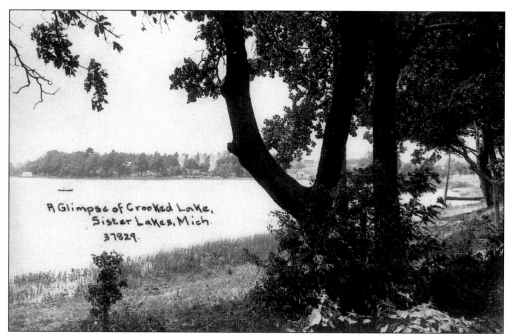

Here is a *c.* 1910 postcard looking at a portion of what seems to be Little Crooked Lake. The photographer taking this photograph was employed by the C. R. Childs Photography Company of Chicago. C. R. Childs's postcards of the Midwest number in the thousands. He developed a numbering system for each location and subject. For the three lakes of Little Crooked, Big Crooked, and Round Lakes, the numbers were 37800 through 37899.

This modern scene is a photograph looking west across Big Crooked Lake at the shoreline. What is seen is a combination of businesses, cottages, and a resort. The group of buildings on the left side is part of Smallbone's Maplewood Resort. The two-story building in the background is Sutherland's Store.

Crooked Lake, Sister Lakes, Mich.

This Big Crooked Lake postcard was taken from the west looking back at the eastern shoreline. This group of cottages is a part of the subdivision called Woodland Point. This parcel of land had been bought by the developer Curtis W. Coates. It was platted in 1944 into lots to be sold along Big Crooked Lake. The road in the development was named Victory Shore Drive.

A View of Crooked Lake, Sister Lakes, Mich.

This angle of Big Crooked Lake was taken from a property at the Woodland Beach subdivision. This land was an earlier subdivision developed by Coates in 1926. C. W., as Coates was called, even had a real estate office in the Chicago Loop to sell lots at Sister Lakes. This view of the lake shows what is called the Narrows of Big Crooked Lake.

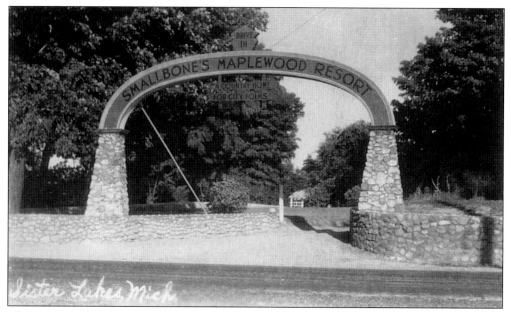

This postcard lets everyone know what a grand place Smallbone's Maplewood Resort was going to be after driving through this arched entrance off Country Road 690. The owners of this resort were Sydney and Helen Smallbone. Part of this property had been originally platted as the Bowlings subdivision in 1911 and subsequently was incorporated into the Maplewood Resort complex.

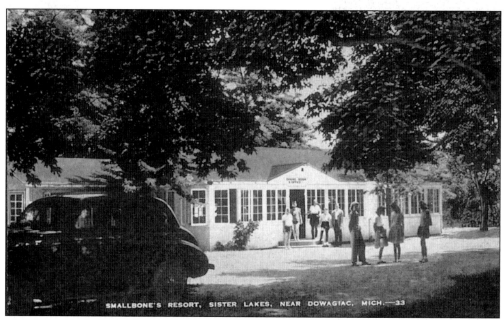

This scene shows the office and dining room at Maplewood Resort. Vacationers are starting to come down from their cottages for lunch. Everyone loved the huge, hearty meals that were offered three times a day. The owner's wife, Helen Smallbone, was in charge of the kitchen, and her chicken dinners were notorious for their quantity and quality.

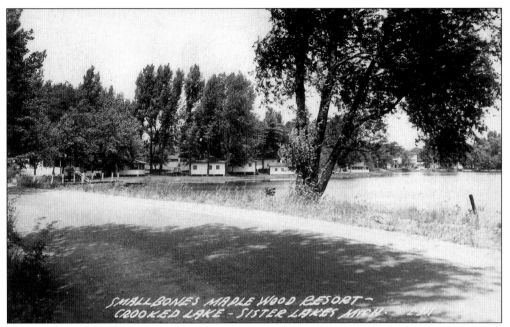

The 1940s photograph above is of Smallbone's Maplewood Resort taken from Ninety-fifth Street. The view is from the east with Big Crooked Lake shoreline on the right side. At this time, the street is still unpaved. Notice the trees that have been whitewashed near the bottom. This was a custom of that era for many resorts, not just at Sister Lakes.

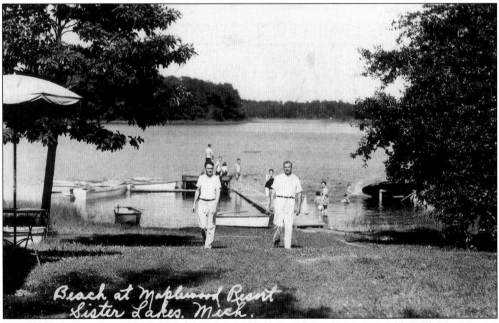

This 1941 postcard is included for a number of reasons. First, it shows part of the beach and rowboats at Maplewood Resort. Second, the man on the right side is Sydney Smallbone, who would spend every day greeting guests and checking the grounds for problems. The last feature is that it is an example of a postcard taken back to Chicago and then mailed with a postmark from the Stockyards post office substation.

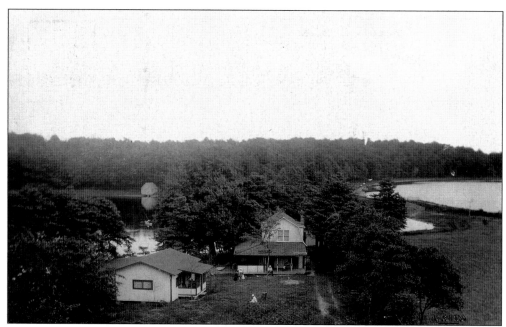

This aerial view is probably one of the first photographs of the Maplewood Resort taken from a plane. It shows an early version of what would become one of the larger resorts of Sister Lakes. Seen in the photograph is the original farmhouse that had a screened-in porch. The other building shown is one of the first cottages.

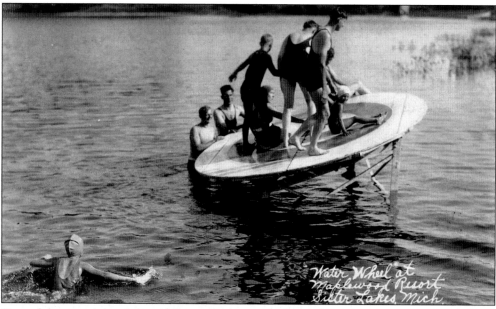

One of the most important and fun activities at Maplewood Resort was to test one's skill at keeping one's balance on the waterwheel. The message on the other side of this 1932 postcard from a young lady to a friend in Benton Harbor states, "This is how I get my exercise every day." The waterwheel was so popular that there was always a line to use it.

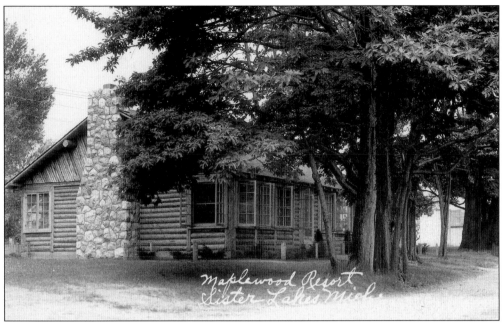

This type of postcard shows one of the types of cabins that were available to rent at the Maplewood Resort. This particular cabin was made to replicate a northern woods experience. It was made of logs and had a large fireplace. All the materials for this cabin came from southwest Michigan. Even the chimney was hand-constructed and made from natural fieldstone.

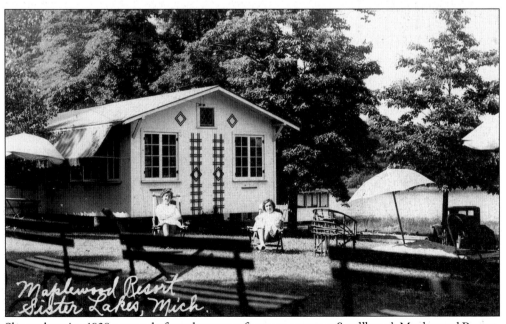

Shown here is a 1938 postcard of another type of cottage to rent at Smallbone's Maplewood Resort. The text on the other side of the postcard tells about two girls having a week vacation at this resort. Consequently these two women in the picture could in fact be the vacationing girls.

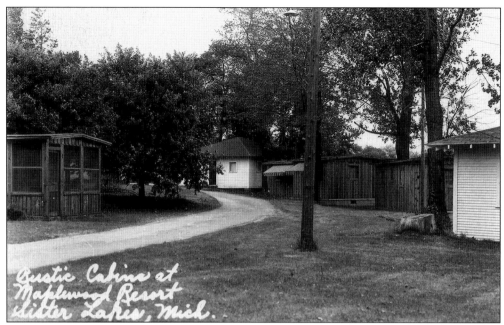

This 1954 picture of cottages and cabins gives a sense of the size of Maplewood Resort. Many families who came for their vacation would rent the same place every summer. In fact, some extended families would plan their vacation so that everyone would be there at the same time. Also, neighbors back in Chicago often would plan to be there together.

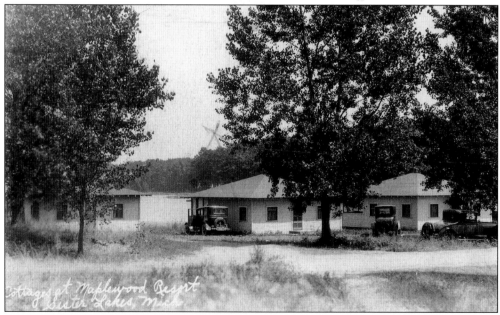

This is another view of cottages at Maplewood Resort, dated August 22, 1935. One of the habits people had when they sent a postcard was to put an X where they stayed. In this case, the couple sending the card put an X over the middle cottage. Also by this time, folks were driving their automobiles to Michigan.

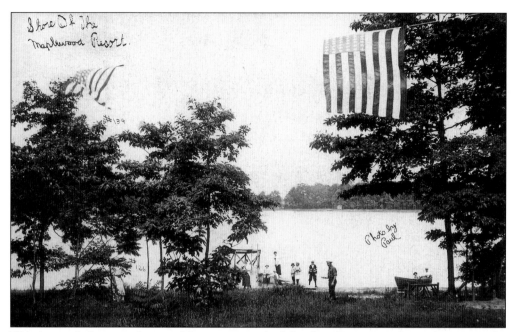

This is a real photograph turned into a postcard of the shoreline at Maplewood Resort. The American flags at the top of the card could have been set out for a Fourth of July celebration. On the right, in very small, handwritten script, is the text "Photo by Paul." This gentleman, Paul Frank, was one of the Sister Lakes photographers who took many of the scenes of the area.

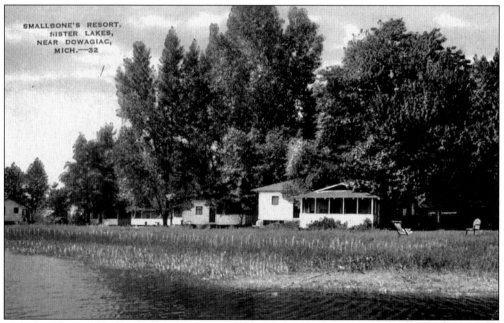

In its original form, this postcard is colorized and known as a linen postcard. This name comes from the texture of the paper that made up these cards. This type of postcard became very popular in the 1930s and 1940s and was made by the millions all over the United States. The Maplewood Resort remains in operation today.

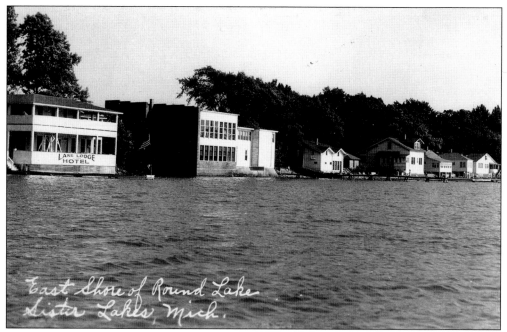

This 1929 photograph was taken from a boat looking at part of the businesses along the shoreline of Round Lake. The first building on the left side of the shoreline is the Lake Lodge Hotel. Records show that at this time the owner of this lakefront resort was Berlin C. Suits. Many of these postcards include a handwritten description of the scene.

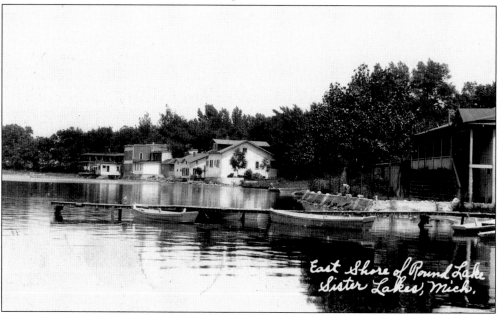

Shown here is another 1929 postcard, probably taken the same day and time. The scene is the east shoreline of Round Lake taken from the opposite direction of the previous postcard. This view shows the combination of businesses, cottages, and private homes side by side along the shoreline. The concrete breakwater belongs to the J. D. Ludwig Store and Bishop's Inn on the right side of the card.

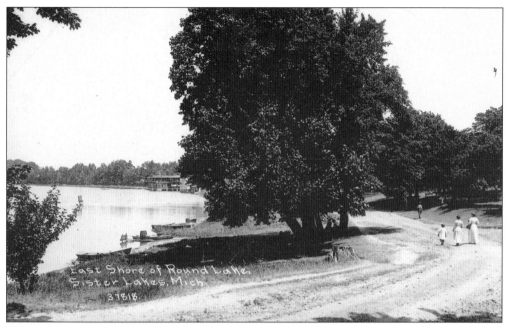

This 1916 photograph shows the east shore of Round Lake. The number on the picture is 37818, which means this was only the 18th photograph out of 100 used for Sister Lakes by the C. R. Childs Photography Company. The two women and little girl are walking toward the business section, which was on Round Lake.

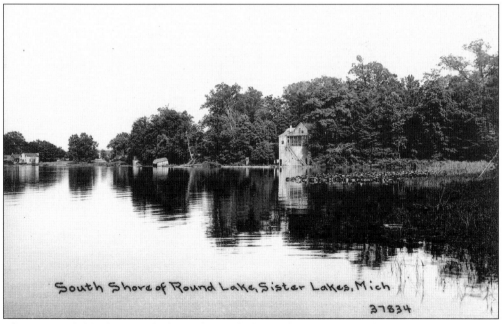

This C. R. Childs photograph shows the south shore of Round Lake. These early photographers spent hours setting up their equipment while trying to take the perfect photograph. This angle of the south shoreline has the photographer renting a boat to capture this scene. Notice the three-story house along the shore that was built as a combination home and boathouse.

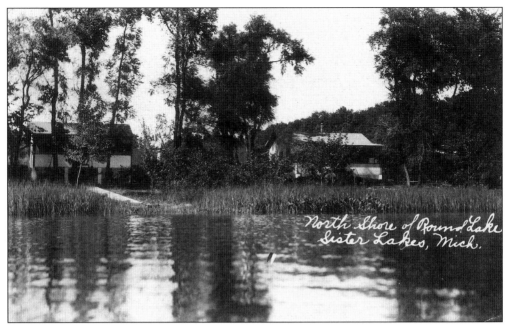

The 1922 scene is of the north shore of Round Lake. This is a classic postcard because it shows two cottages, and on the other side is the message "Having a wonderful time, wish you were here." At this time, the north end of Round Lake was still very natural in vegetation.

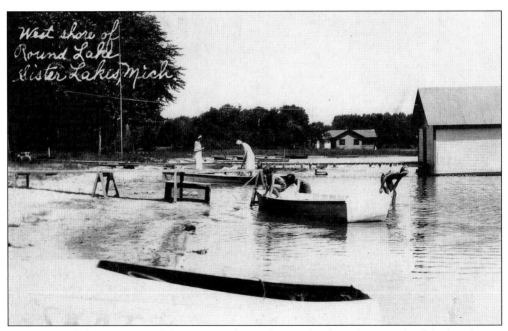

This postcard shows a strip of the western shore of Round Lake. The view is of the beach area of what is known as the Oak Park subdivision. This section of land was platted in 1913. Most of the lots sold had 50 feet of lake frontage and were 100 feet deep. Notice how far out from the shoreline the boathouse was built.

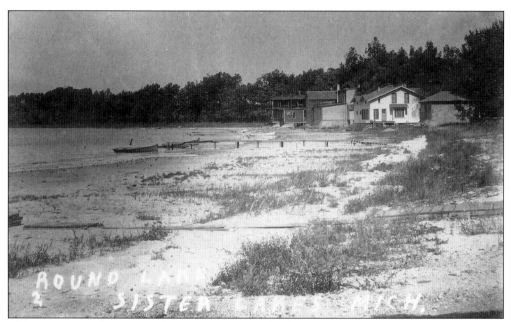

The 1923 view of Round Lake shows it at one of its lowest levels. Check out how far out the piers had to be built to accommodate boats. This photograph was taken of the beach area after the water had receded, and it is at the site of the future Driftwood Summer Shop, looking north along the shoreline.

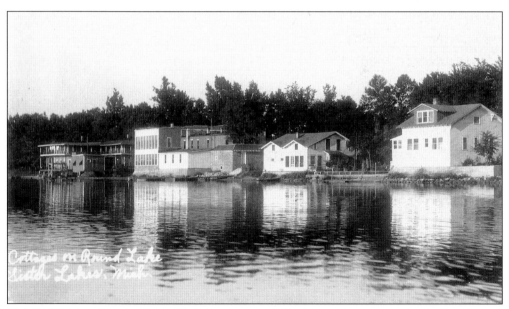

This 1942 postcard shows Round Lake at approximately the same location as the previous image, with the water back to a more normal lake level. These changes in water levels in the lake have periodically occurred. Because this is a spring-fed lake, the highs and lows are a natural occurrence that can last for years.

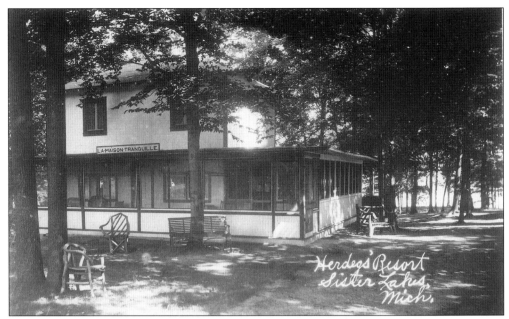

This photograph of the main building of Herdeg's Resort on Big Crooked Lake is from 1928. The resort was started by George and Rosa Herdeg, who came from Chicago about 1913. Notice the name of the house in French called La Maison Tranquille. This was Rosa's influence, as she had emigrated from the French-speaking part of Luxembourg to Chicago in 1881.

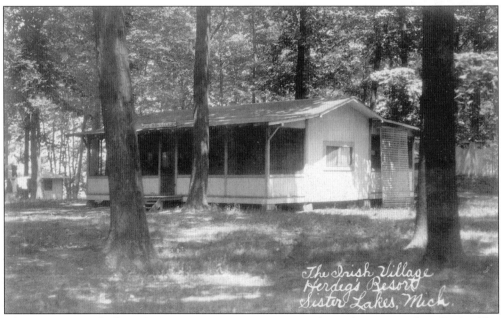

The 1938 postcard of Herdeg's Resort can cause some confusion because it identifies itself as the Irish Village. This particular cottage had that name, but the real Irish complex of people and cottages was on Dewey Lake. At Herdeg's Resort, there were seven or eight cottages where vacationers stayed, and they ate their meals at the main house.

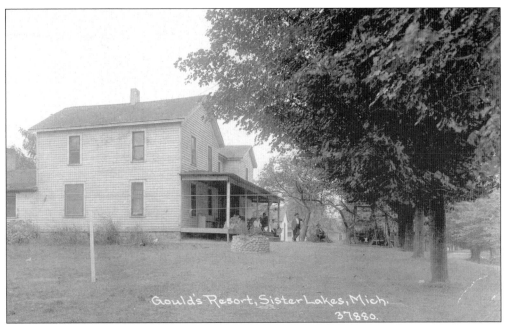

The Gould's Resort in this postcard is a good example of a farmhouse and farm becoming a resort. On the other side of this postcard there is a stamped advertisement for "C. R. Childs, 5707 South Blvd., Chicago, IL, Publisher of postcards, booklets, etc." A photographer from the C. R. Childs Photography Company identified this resort as number 37880 in its series of Sister Lakes postcards.

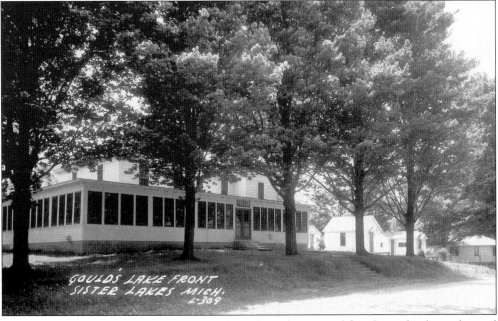

This 1940s photograph of Gould's Resort shows how the original farmhouse has been changed and remodeled to accommodate vacationers. The front porch has been enclosed with windows and screens. On the right side of the hotel, the group of cottages was also part of this resort. In a 1936 brochure, the owner, Ora Gould, advertises for boarders and has cottages.

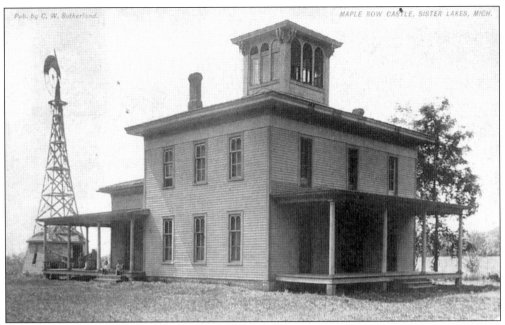

The 1910 postcard shows the farmhouse called Maple Row Castle. The original farm was built in 1861. In 1878, Ora Holt Makyes and his family bought the 100-acre farm. The house had 12 large rooms that were paneled with lumber from the area. In the background on the right side of the house, part of Round Lake can be seen.

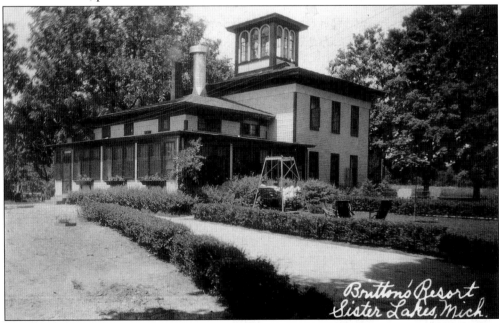

This 1940 postcard shows the Maple Row Castle now being called Britton's Resort. This was because William Britton bought the property and continued to rent to vacationers. One of the unique features of the house was the winding staircase to a third-floor cupola. The house was eventually torn down, and a gas station took its place. The remaining barn across the road became the Sister Lakes Playhouse.

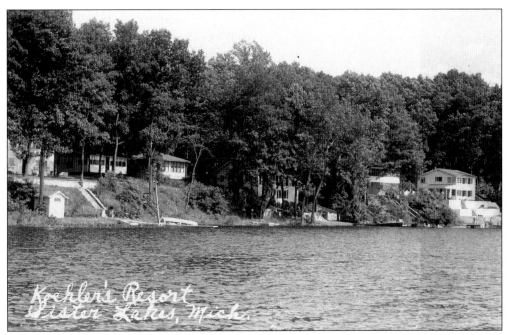

Koehler's Resort was located on the east shore of Little Crooked Lake. As shown by the photograph, these cottages were located on the higher ground. Stairways built down to the beach were either of concrete or wood. The type of stairs the cottage had was sometimes used as a subtle symbol. The cottages ranged from very basic to very elaborate structures.

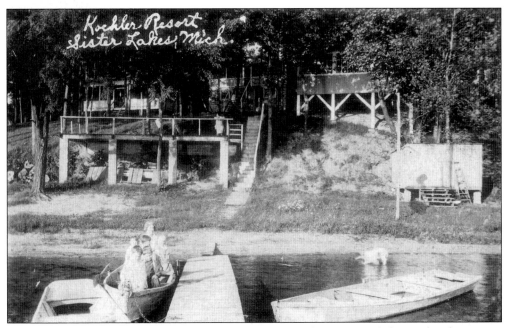

Another view shows Koehler's Resort in a 1938 postcard. There is a good chance that this picture was especially taken for this group of people. On the left side of the pier is the tied up rowboat. A woman and five children are inside, looking at the photographer. It would be hoped that she was really not going to take that many children out in that small rowboat.

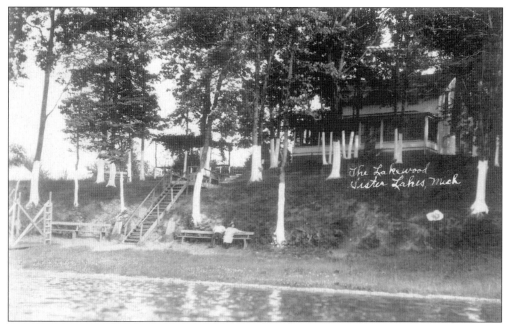

This 1924 scene is of the Lakewood Resort. From the angle of the photograph, it is hard to tell if this was one large resort building. The owner, Mrs. E. Pries, advertised accommodations for 90 guests. The assumption is that there were also cottages on the property. Her advertisement also said, "You would like the homelike atmosphere and our congenial clientele."

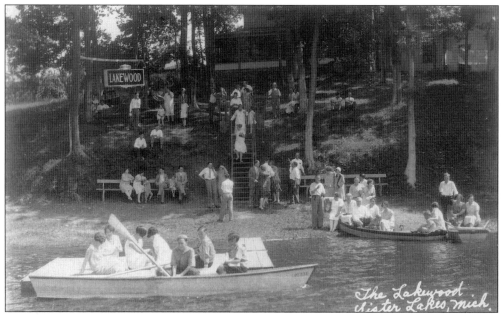

The posed photograph is of everyone at the Lakewood Resort that could be found to have their picture taken that sunny day of July 22, 1929. Notice the bobbed haircut of the ladies sitting on the pier. The weekly rates for this resort were $15 per week for a double room or $16 for a single. Those prices included the room, meals, and the use of boats.

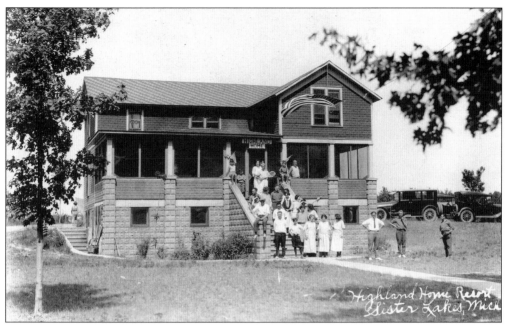

The Highland Home Resort in this photograph is another farm and farmhouse turned into a resort for the summer months. This farm was owned by Lewis and Sarah Timmons, and they grew grapes, apples, and peaches on their 40 acres. They had a huge garden, which produced most of their vegetables for meals. The weekly vacationers loved to help pick fruit and vegetables for their meals.

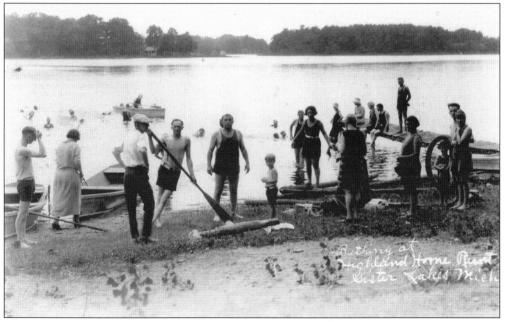

Once again, here is a postcard describing the bathing going on, this time at the Highland Home Resort. The beach shoreline was very undeveloped at this part of Crooked Lake. As shown in the photograph, the lack of a sandy beach did not stop anyone. Everyone in this picture was ready to enjoy the water, even if the postcard did not say they were swimming.

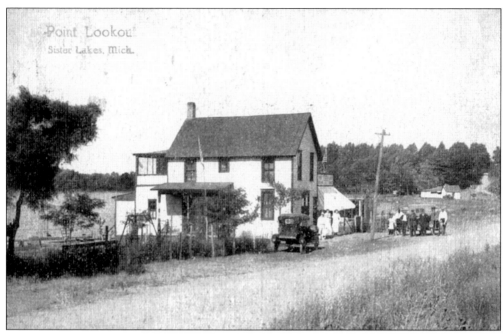

The 1921 postcard is identifying Point Lookout on Round Lake. But, in fact, the center of attention in this card is Mamie Kiefth's general store and home. Kiefth ran the store until one of the Link Brother clowns of the Barnum and Bailey's Circus bought the store and ran it until 1957.

This postcard is from the 1920s. It is from the other side of Kiefth's General Store and shows the cottages that were a part of the business and property. After buying the store in 1957, Adolph and Ruth Dill continued to do business in this location until the 1970s. At that time, it was converted into a private home.

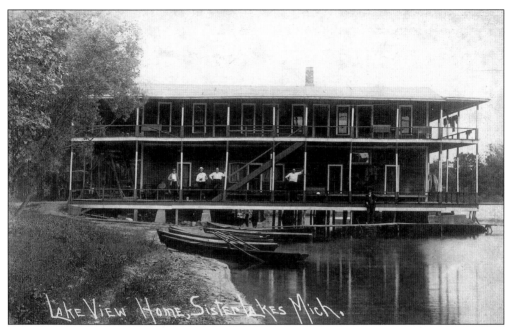

The waterfront hotel in the postcard dated August 8, 1916, was first called the Lake View Home. It is typical of how some of the early resorts were built partially over the water. The other side of the postcard is an advertisement for "one of the best resorts in the country." It also stated, "Our food is second to none and the service is high class."

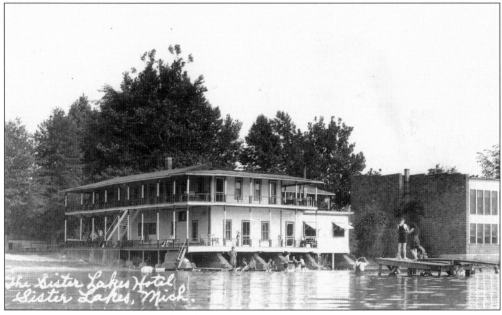

By 1933, the Lake View Home had changed owners and was now being called the Sister Lakes Hotel. One of the obvious attractions of this hotel was its location. Mothers could sit outside their rooms and watch their children play and swim. Nowadays it would be called an all-inclusive resort because everything was provided for guests on-site. It eventually became the Lake Lodge Hotel.

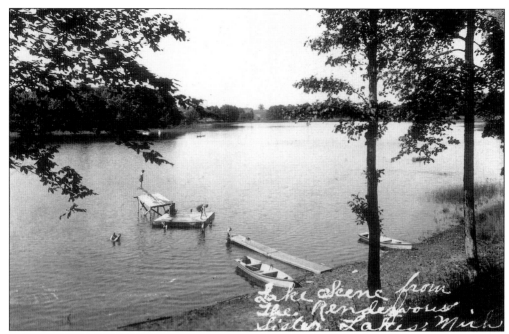

This view of Big Crooked Lake was taken from the Rendezvous, which was a restaurant and bar owned in 1951 by Andy Anderson. This building had previously been a rooming house and had been turned into a tavern. Across the street was the Rendezvous Racetrack, which drew thousands of spectators and now is the site of Lions Park.

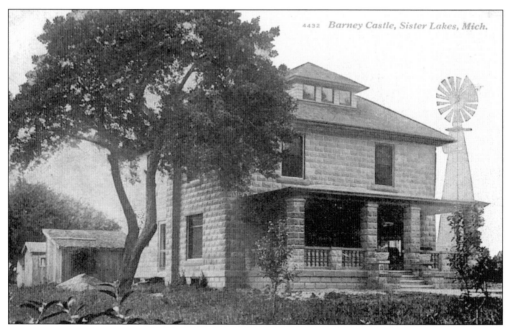

Barney Castle was a farmhouse turned into a summer bed-and-breakfast. This building, which still stands (minus the front porch), is by Round Lake. The concrete blocks that were used to build the house were from a gravel pit on the property. A 1912 plat map shows this 40-acre property belonging to B. D. Makyes. Notice the fake windmill that was added to the photograph.

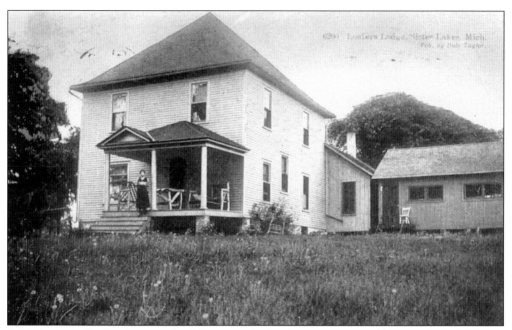

A 1915 scene of a farmhouse turned into a resort for the summer months is seen here. This one was called Loafers Lodge and was owned by Asa Lewis. This farmhouse shows how as business increased so did the size of the house to accommodate vacationers. Standing on the front porch is the owner's wife, who was usually in charge of all the cooking and cleaning for guests.

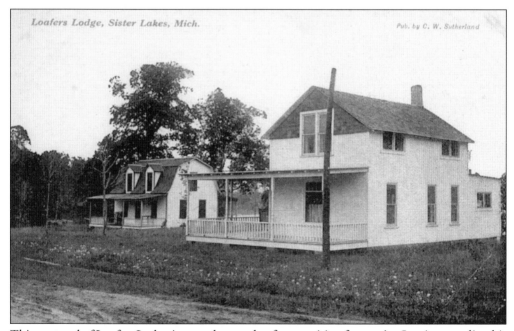

This postcard of Loafers Lodge is a good example of enterprising farmer Asa Lewis expanding his business. He has added two more good-size cottages to his farm. One of the interesting features in this photograph is the utility pole in anticipation of added electricity. In the background between the two houses, a sliver of Round Lake can be seen.

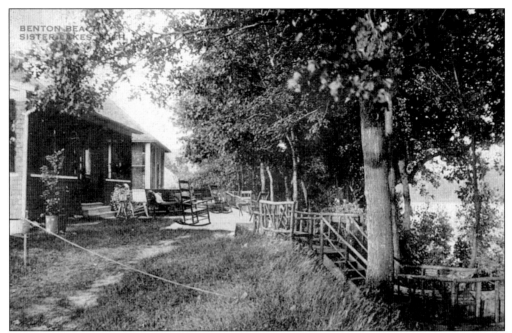

This 1913 view shows a couple of the cottages at Benton Beach on Round Lake. This land was platted and subdivided into 20 lots by Frank F. Pratt in 1904. The lots averaged 60 feet of lake frontage. On the other side of the card, a vacationer tells how it was too hot to fish in the daytime, so he went out in the moonlight and was very successful.

The 1938 photograph shows the sign for Anderson's Oak Hill Farm at Crooked Lake. The owner was Carl Anderson. A 1940s Dowagiac Chamber of Commerce brochure advertises this place as a farm, resort, and cottages. Many of these farms were able to grow and prosper because of the added income the vacationers provided. In some years, due to poor weather and poor harvest, this money made the difference in survival.

Shown on this postcard are five cottages on the north side of Round Lake. The correct spelling for this location is Pitcher's Beach. In 1922, Claude Pitcher sold part of his farm along the lake to a developer for a subdivision of cottages. On the west side of that property, he deeded a 10-foot public access to Keeler Township. Pitcher always wanted his cows to have lake access.

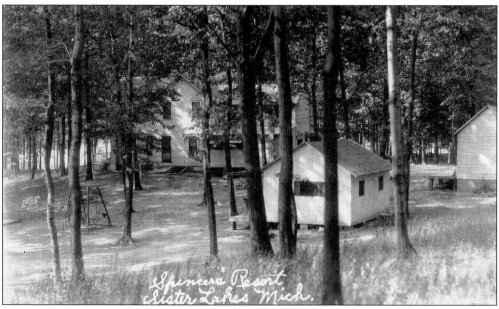

The 1929 photograph shows a part of what was called Spencer's Resort. This group of cottages was on the east side of Little Crooked Lake. They would have been off what is now called Wildwood Drive. This parcel of land was platted and subdivided into lots by William Spencer in 1912. There were originally 15 lots with lake frontage.

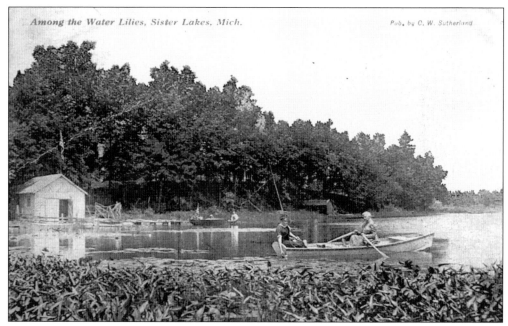

Most lakes and resort areas had this type of generic scene for sale as postcards. They typically showed a rowboat among the lily pads of a particular lake. Since these lakes all had these lily pads in common, the card could be from Big Crooked, Little Crooked, or Round Lakes. This card just says, "Among the Water Lilies, Sister Lakes, Mich."

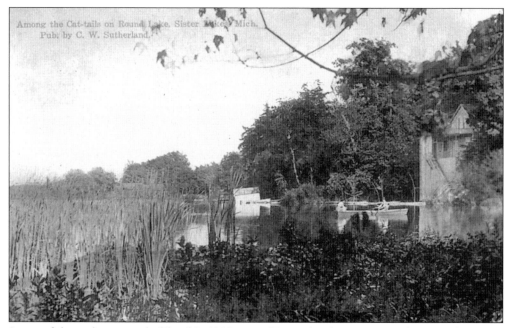

Some of the early postcards, like this 1908 one of Round Lake, were in color. But they were first taken by a local photographer in black and white and then sent to Germany to be colorized. They would then be sent back to be sold to the local market. This coloring process had not yet been developed in the United States. World War I ended the practice.

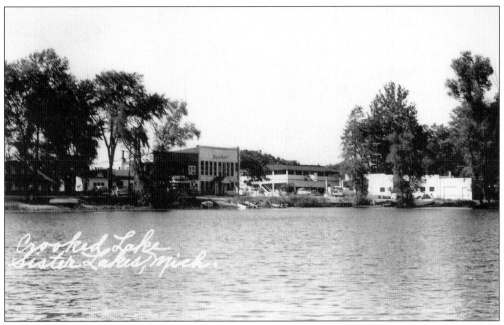

The August 21, 1956, postcard is a view from Crooked Lake. It shows part of the businesses along what was called the strip or midway. All these buildings, except the filling station–garage combination, are on the other side of the road facing Round Lake. The two-story building with all the windows is the Sandbar Tavern.

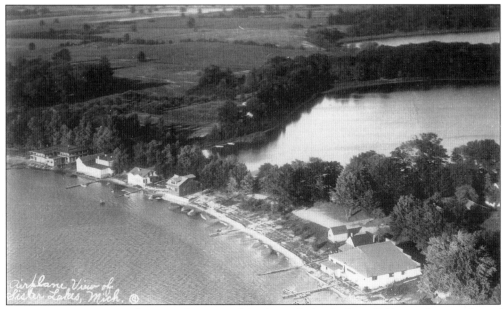

An enterprising young photographer named Paul Frank, in the late 1920s, took a number of photographs of the Sister Lakes from an airplane. This scene gives a view of the businesses along the Round Lake shoreline. The first building on the right side of the card is Bishop's Inn and the J. D. Ludwig Store. At the far left side of the card is the Lake View Hotel.

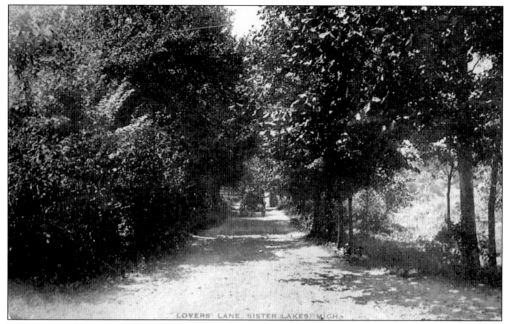

This postcard is a 1911 view of the "Lovers' Lane" at Sister Lakes. Many resorts had a path or road designated for romantic walks. For many young couples, their honeymoon was spent at Sister Lakes. This particular lane even developed into a highway for automobiles. An early car can just barely be seen on the road.

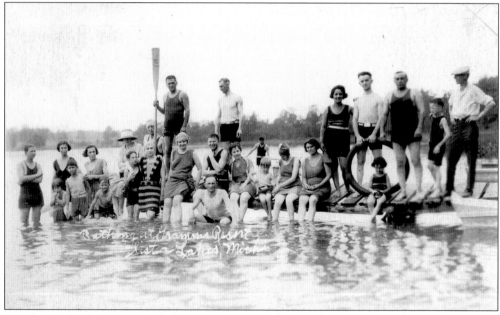

This is the same postcard that is seen on the cover of this book. It was chosen because it captures the magic of summertime on one of southwest Michigan's lakes. Shown in this 1920s photograph is a true cross section of people, bathing suits, and ages, ready to enjoy the activities available at one of the many resorts of Sister Lakes. Everyone can imagine being one of these folks and sending this postcard back home.

Four

DEWEY LAKE

This is a roadside view of part of Dewey Lake. The lake was named for Henry and Nancy Dewey. They were part of the first group of settlers who came to this area in 1831. They subsequently had 14 children and acquired some 600 acres around the lake. One of the reasons Henry chose this lake when he visited was because it was alive with fish.

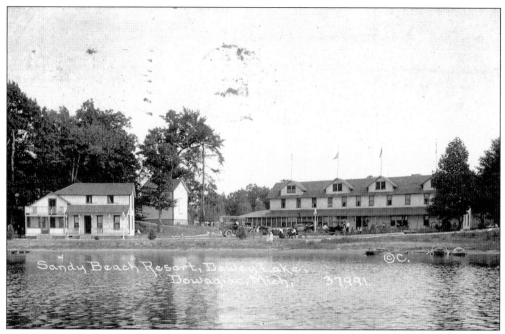

A 1917 postcard shows Sandy Beach Resort taken from Dewey Lake. This is another photograph from C. R. Childs Photography Company. It gave Dewey Lake the 37900 to 37999 numbering system. There are postcard collectors who just try to collect every postcard in each series. This view shows only part of the large resort's many buildings.

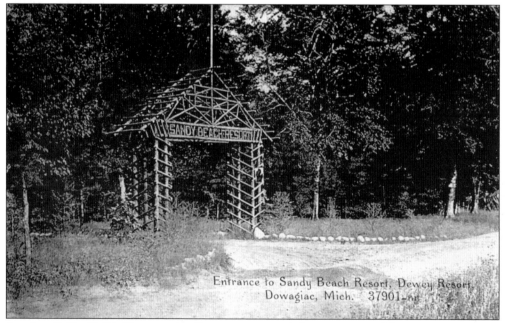

Another C. R. Childs Photography Company postcard, from 1926, is of the entrance to Sandy Beach Resort at Dewey Lake off the main highway. The elaborate wooden structure was made to foster the impression of being in the woods. Some of the early advertisements for this resort emphasized the forestlike atmosphere vacationers would be enjoying.

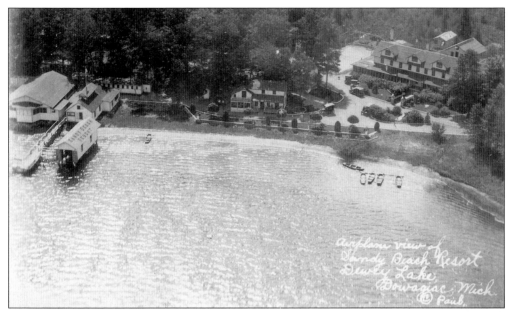

This late-1920s aerial view is part of the series of photographs that photographer Paul Frank took of the Sister Lakes. Because he was probably one of the first aerial photographers, he had his pictures copyrighted. This airplane view gives a better idea of the size and types of buildings at Sandy Beach Resort.

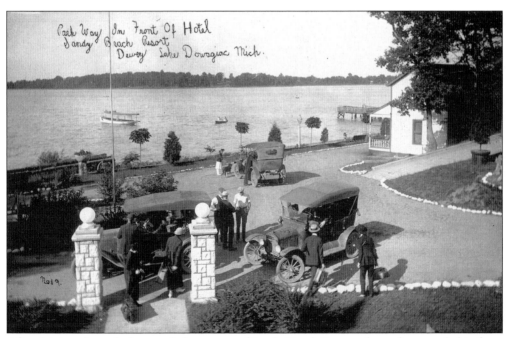

After driving through the wooded entrance of Sandy Beach Resort, the parkway ended in front of the hotel. This group of cars consists of taxis, which have come to pick up passengers. This particular group of folks seems to be leaving for its train connection in Dowagiac to return home. Notice the formal entrance to the hotel and excursion boat that is out in the lake.

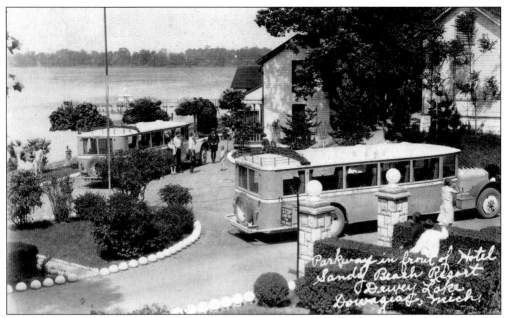

This 1926 postcard shows another form of transportation to and from Sandy Beach Resort. During the busy 1920s, the owner of Sandy Beach, F. E. Tarrant, had a contract with a private bus company. This company, out of Chicago, would pick up vacationers and their luggage on a regular schedule and bring them to Dewey Lake. Check out the uniformed driver standing by his bus.

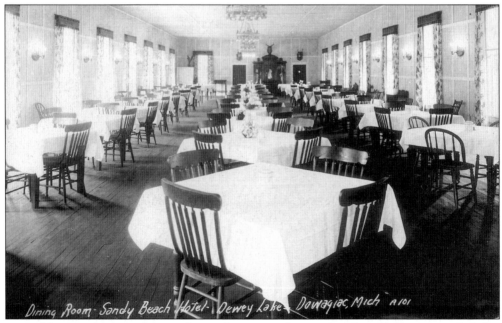

One of the great features of resorts during this era was the wonderful meals that were included in one's package. Shown here is a part of the main dining room located in the hotel. A brochure from the 1920s says the dining room could handle up to 400 people. The staff members that prepared, cooked, and served all the guests were, for the most part, residents of the community.

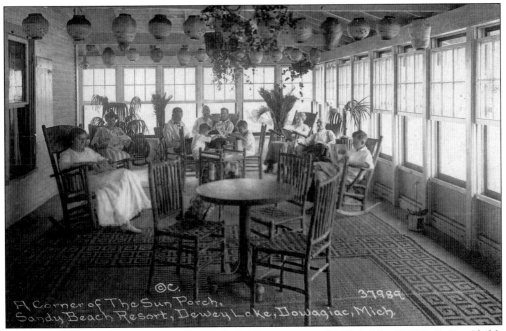

The main hotel at Sandy Beach Resort had a huge sunporch. This No. 37989 C. R. Childs Photography Company postcard shows a corner of that porch. This area was quite important because it gave everyone at the hotel a place to mingle and socialize. As can be seen in the picture, reading and rocking was a favorite pastime.

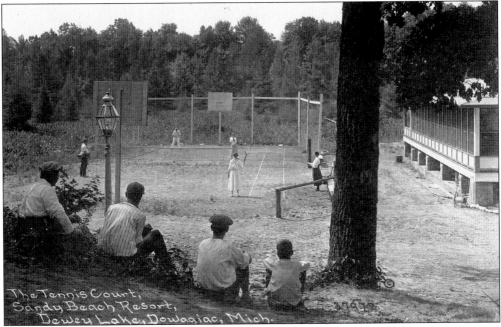

Typical of all resorts were the many and varied activities that guests could participate in. This scene shows the combination tennis and basketball court being used for tennis that day. The court was also set up with some type of outdoor lighting. Notice the lamppost strategically placed for night lighting of the area. Another great activity was just being a spectator.

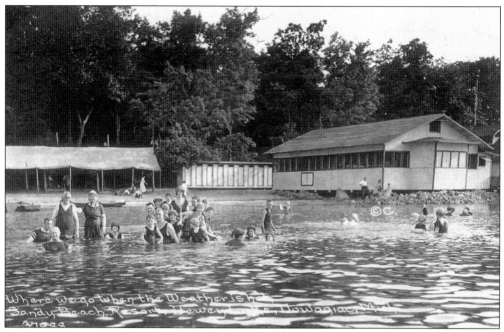

The 1911 scene is of the beachfront at Sandy Beach Resort. It is assumed that the C. R. Childs Photography Company photographer is in a boat for this posed picture. Check out the bathing suits and primitive caps the women all wore. In the middle background are the changing rooms for the bathers. It was not proper to undress before others, even those of the same sex.

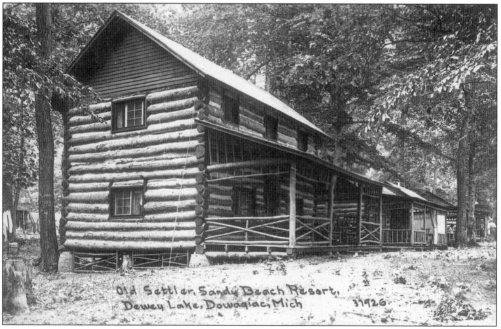

Sandy Beach Resort was one of the largest resorts on the Sister Lakes. At capacity it could accommodate up to 500 people. This 1916 view shows one group of cottages at the resort. The large two-story log cabin called the Old Settler was very popular. It had space with cots for a family of up to 10.

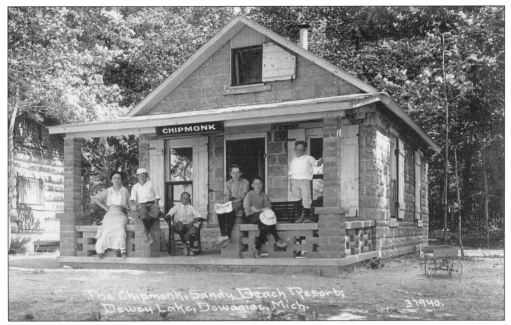

All the cottages at Sandy Beach Resort had unique names. Another attraction was the variety of cabins or cottages available. This 1914 postcard is a view of a concrete block cottage called the Chipmonk. Many families would reserve the same cottage year after year. Another characteristic of all these cottages was a front porch to socialize.

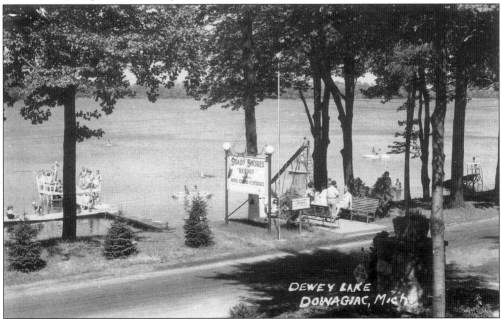

Shady Shores Resort came into existence because Frank N. Nevins liked fishing for bluegills. In 1926, while trying to catch some fish at Dewey Lake, Nevins was approached by the local game warden and asked for his license. During their conversation, the officer mentioned that he had a lot to sell on the lake. Because of the great fishing and great price, Nevins and his wife, Esther, bought the property.

This postcard shows some of the cottages at Shady Shores Resort. After buying his lot in 1926, Frank N. Nevins quickly built a cottage for his family. Each year he would add to the property and had more cottages built. By his death in 1942, the resort had grown to 60 buildings over 30 acres.

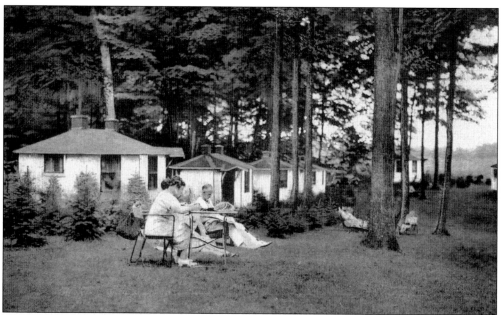

This postcard of Shady Shores Resort shows a different type of cottage. While Nevins was in Chicago for the 1933 world's fair, he ran across a company selling prefabricated houses. At that time, other companies, like Sears and Roebuck, were selling kits for houses but not the actual structures. Nevins liked them enough to have a number of them shipped to Sister Lakes to be erected as cottages.

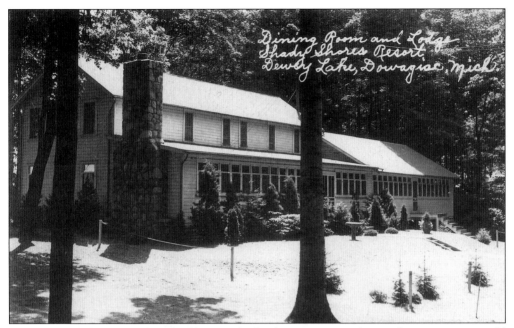

This postcard shows the main building at Shady Shores Resort. This is where resorters would come for their meals if they had chosen the American plan for eating, which offered them three hearty meals a day. A large bell, taken from an old steam engine, would be rung to announce mealtime. Upstairs in this building were the dormitory rooms for female college students who helped run the resort and acted as waitresses.

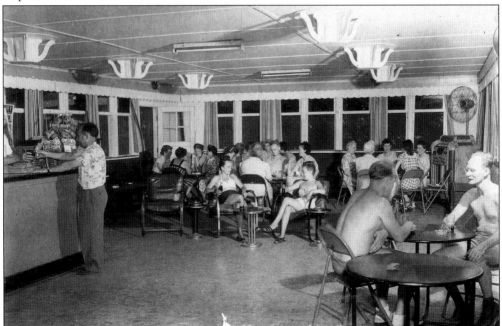

The 1951 postcard gives a picture of part of the inside of the main building, called the lodge. This addition provided an informal place for games, drinks, and socializing. To operate the Shady Shores Resort, the Nevins family had a manager, 14 female college students, and 10 male college students who were primarily from Blackburn College in Illinois.

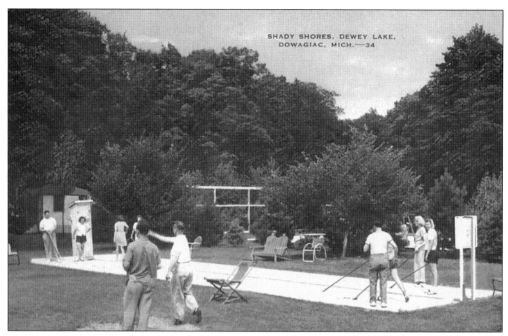

Every resort had to have a shuffleboard court, and Shady Shores Resort was no exception. Because the resort was family owned and operated, everyone had a part in running it. After Frank N. Nevins Sr. passed away, his son, Frank Jr., and wife, Alice, came back home to help. As their four children were born, starting with Richard and continuing with Bruce, Phillip, and Lynette, they were assigned jobs when they became of age.

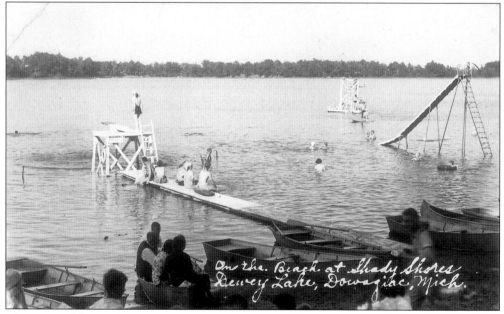

This postcard from July 12, 1939, is of the beach at Shady Shores on Dewey Lake. The very large and sandy beach was across the road from the resort and cottages. As can be seen, there was a big slide, a raft with a diving board, and another platform diving board at the end of the pier. Rowboats lining the shore were used from early morning until late at night.

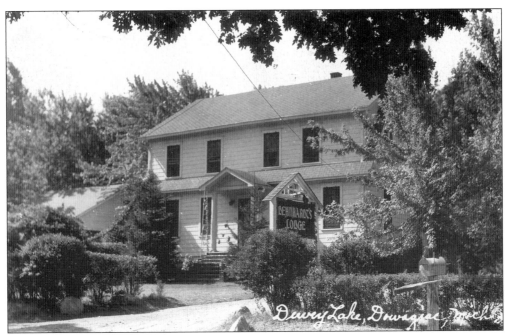

The 1943 postcard is a view of the Dehnhardt Lodge at Dewey Lake. It was located next to the Shady Shores Resort. The upstairs had six bedrooms to be rented daily or weekly. The owners, Alfred and Anna Dehnhardt, operated the lodge until Alfred tragically drowned in 1937. They had no children, but Anna was able to continue to run the lodge by herself into her 80s.

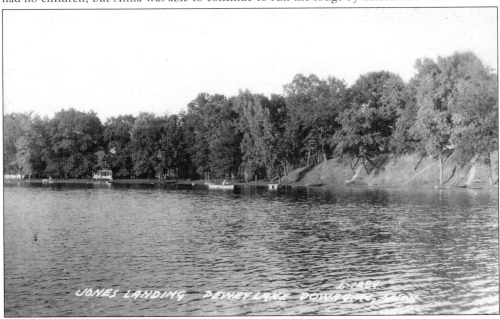

This photograph is a view of the east shoreline of Dewey Lake named Jones Landing. Mary Jones Brooks platted the property in 1924 and called the subdivision Dewey Brook. There were 84 lots divided into three blocks. Of these lots, 48 were lakefront. This landing soon became known as the Irish Village due to the number of Chicago Irish families that bought lots and built cottages there.

Garrett's-Farm Home Resort near the Lakes, near Dowagiac, Mich.

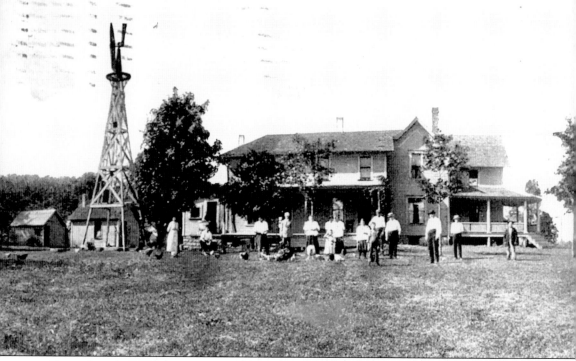

Shown here is Garrett's Farm Home Resort, which is an example of one of the area farms also becoming a summer resort. What follows is some text from a 1915 brochure. "If you want to really enjoy your vacation at a small cost and if you want to live the simple life on a 140 acre farm, Garrett's Farm offers rolled lawn for tennis, baseball diamond, croquet and games." It then describes the different kinds of activities the farm and surrounding area had to offer. Vacationers had the opportunity to go hunting, fishing, swimming, or boating, all near the farm. Every day there was all the fresh fruit, eggs, and milk one could eat and drink. The resort could hold up to 40 people at a time. The cost for food and lodging was $7 per week. No children were allowed in the month of August.

Five

INDIAN LAKE

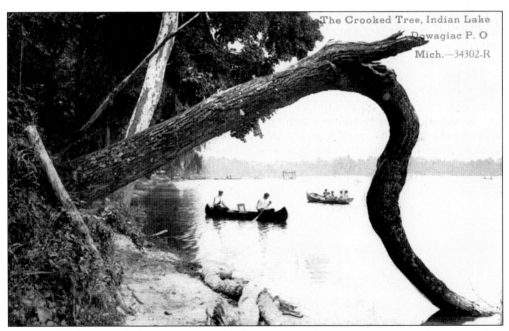

The Crooked Tree, Indian Lake
Dowagiac P. O
Mich.—34302-R

This postcard was mailed on June 14, 1914, showing people in a canoe and rowboat on Indian Lake. During this early era of taking pictures, photographers were always looking for some natural feature that was unusual and could be identified with that location. In this case, there is the "Crooked Tree" on the shoreline of Indian Lake. Unfortunately the tree and location have been lost to time.

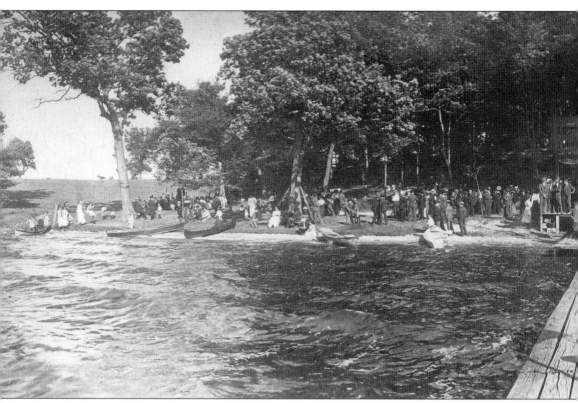

In a collection of over 6,000 postcards of southwest Michigan, this double postcard is one of only 6 that have been found of this area. These double postcards could be mailed but were never practical to send or receive, as they tended to get torn or damaged. Consequently they never became popular and very few were ever made. This scene is of Tuttle's Landing at Indian Lake

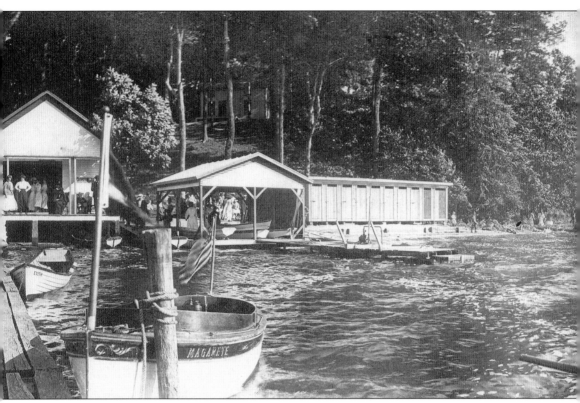

around 1906. A special event or some fraternal organization's picnic has brought everyone to this landing for this special afternoon. The beauty of the photograph lies in the detail of a space in time at Indian Lake. It is not hard to imagine that everyone there had a memorable experience.

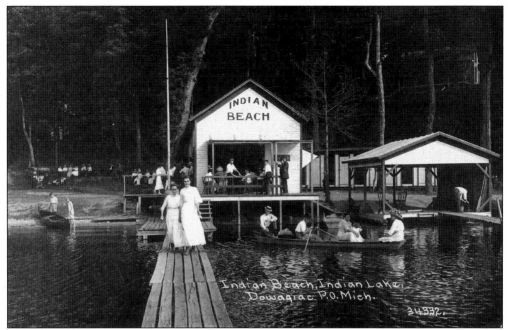

What was originally called Tuttle's Landing had, as shown by this 1913 postcard, been renamed Indian Beach. Even in the middle of summer and on vacation, men and women were always properly dressed. Men wore white shirts and hats while women wore full-length dresses. This is now the location of the Indian Lake Yacht Club.

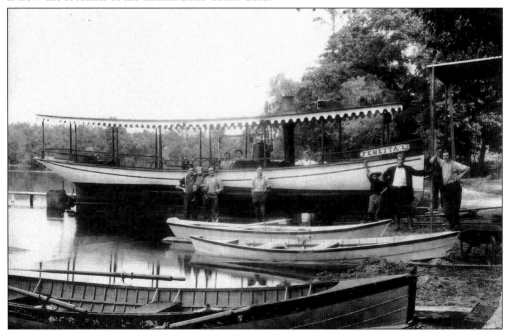

The boats in this photograph show a cross section of the type of boats used on Indian Lake. The largest boat is a steam-powered excursion craft called the *Fenetta L*. It was built in 1901 for W. E. Tuttle and was named for his wife. In later years, the *Fenetta L*. was scuttled, and it lies on the bottom of Indian Lake directly out from the Indian Lake Yacht Club.

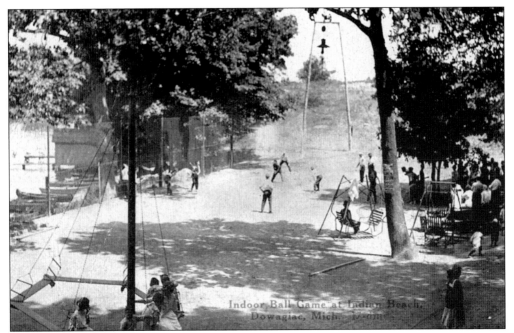

This 1918 postcard is titled "Indoor Ball Game at Indian Beach." One can assume that the photographer got the words *in* and *out* mixed up. The written side of the card is addressed to Geraldine Griffins from Thelma, stating that she is camping at Indian Lake this week. For many young people, coming to Sister Lakes meant tenting and camping because of the cost.

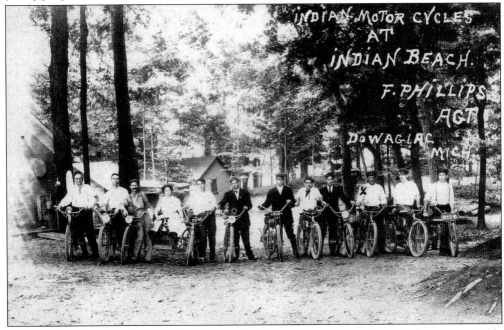

As shown by this early photograph, motorcycle rallies are not necessarily new phenomena. Only the size and complexity of the machines has changed over time. This 1915 group at Indian Beach is ready for a day of riding around the countryside. One of the cyclists even has a sidecar for a young lady and her dog.

This 1909 postcard is from the Indian Lake Club (later the Indian Lake Yacht Club). By this time, cottages had been built at this location and were available either for the owners or guests. In fact, a whole secondary market of rentals had come into existence. This scene shows two young men, one in a hammock and the other leaning against a tree, passing away a lazy afternoon.

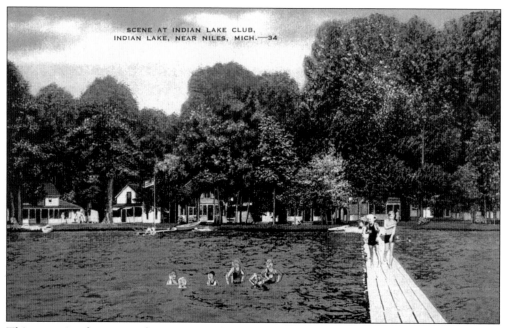

This scene is of a group of cottages on the east side of Indian Lake. The land along this side of the lake was part of the original Conklin Farm. Instead of selling lots, this family and its descendants lease the land. People in turn build their cottages but do not own the land. This process has been working for generations.

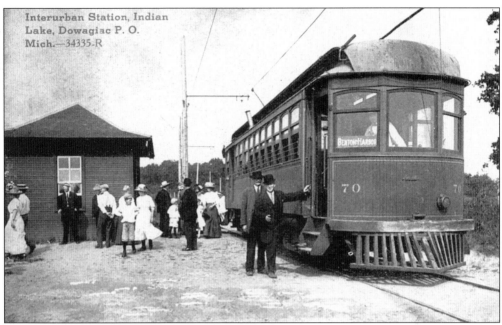

One of the reasons Indian Lake was so popular was that it could be directly reached by the interurban. This 1913 postcard shows passengers boarding the electric train at the Indian Lake station. After disembarking, people either walked or were driven by buggy to the lake. This railroad ran from Benton Harbor to Dowagiac with 14 stops along the route.

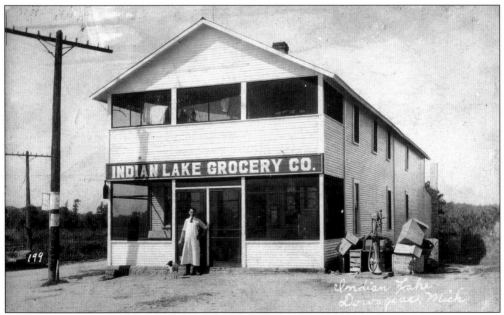

In 1911, the interurban, or the officially named Benton Harbor–St. Joe Railway and Light Company, finished laying track to Dowagiac. Businesses quickly sprang up all along the route. This Indian Lake grocery store was located at the northwestern corner of M-62 and Indian Lake Road. The gentleman standing in the doorway is owner Sigmund Patz, who lived on the second floor with his family.

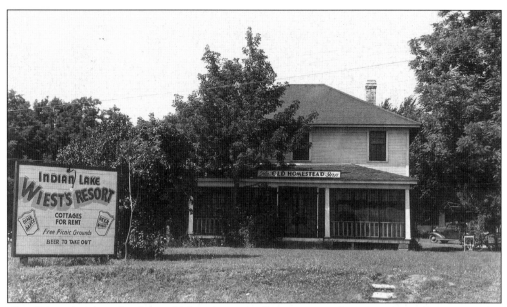

The 1930s photograph of the old farmhouse includes a sign advertising Wiest's Resort. This picture personifies why the resorts of Sister Lakes were so popular. Earl Wiest Jr. took a family farm that just happened to have some lake frontage into a new era. The farmhouse became a bed-and-breakfast, and the crops became paying vacationers.

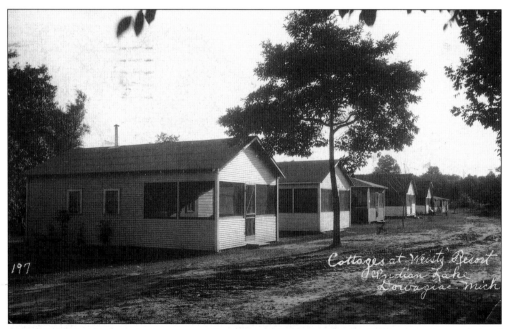

This 1922 photograph shows a row of cottages at Wiest's Resort. These cottages are good examples of keeping up with the public's needs. A cottage with screens could make all the difference whether guests stayed at this resort or another. On his property, Wiest had a dancing pavilion, cottages and lots for sale, picnic grounds, and water amusements. There was something for everyone, young and old.

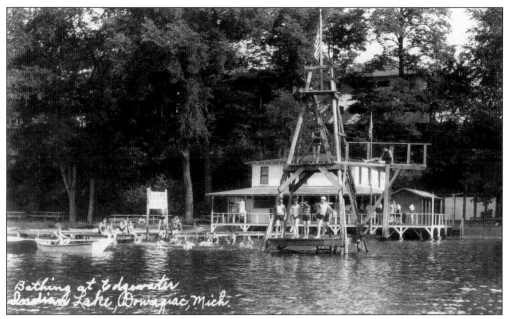

The 1920s postcard shows just a section of the shoreline at Wiest's Resort. The description on the card identifies the house and beach as the Edgewater. In fact, family member Jesse Wiest operated this part of the resort. The three-story diving apparatus is a good example of Earl not willing to settle for just a common diving board.

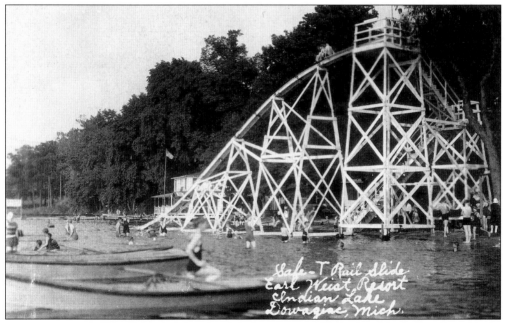

One of the highlights of staying at Wiest's Resort was having the nerve to ride in the Safe-T Rail. This photograph shows the three-story wooden slide at the lakefront. One or two people would carry a slide with wheels to the top, sit down, push themselves off, and end up propelled into the water. This was obviously before liability insurance was an issue for owners.

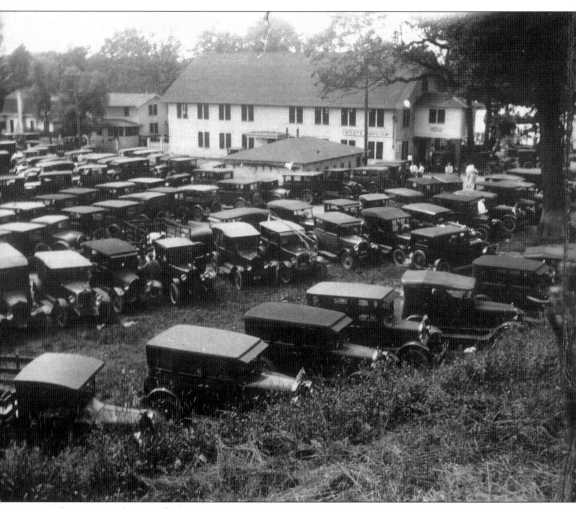

While researching information about Wiest's Resort, this old torn, taped–together double postcard with a corner missing was found. It was just too rare and wonderful a photograph to leave out of this book. What is seen here is a Saturday afternoon in the 1920s at Wiest's Resort and dance pavilion. This photograph captures the joy and fun of a vacation at Sister Lakes. Here

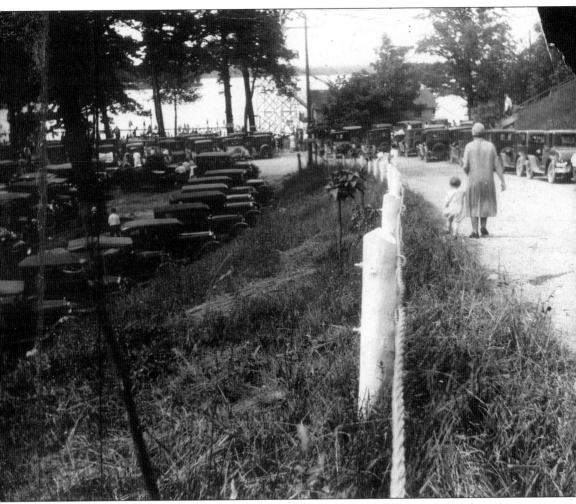

was a day for everybody to enjoy. Local people and vacationers had come to participate in one of the many activities taking place that day. Most of the cars seen in the picture had brought people here for dancing at the pavilion, which had a full-size orchestra. To enter the building, it cost gentlemen 75¢ and ladies 25¢. (Courtesy of Dowagiac Public Library.)

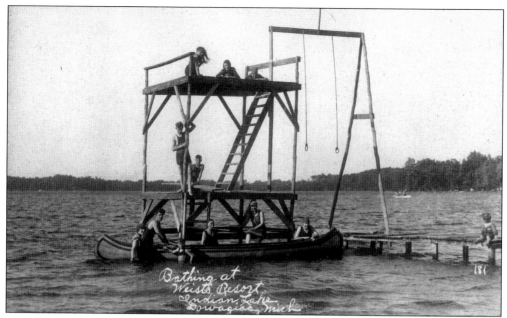

This photograph shows one of the diving platforms at Wiest's Resort. Here again is an example of a simple platform being turned into an elaborate water playground. This type of structure in the water was seen all along the shorelines. All the resorts had fleets of canoes and rowboats that were free for guests and could be rented by the public.

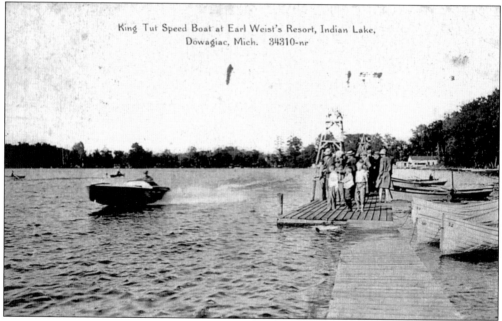

The photographer taking a picture of the speedboat *King Tut* in 1929 had no idea of its significance. Earl Wiest Jr. and Ralph Tice, owners of Tice's Beach at the north end of Indian Lake, were intense rivals. Who had the faster boat was an example. Tice won this round by building *King Tut*, the fastest boat on the lake, and racing it in front of Wiest's Resort.

This view shows the Never Mind Hotel from Indian Lake. By the 1920s, Sister Lakes was one of "the places to vacation," especially for South Side Chicagoans. Every year new hotels and resorts were being built to provide accommodations for the thousands of people coming every week. This hotel, owned by Mr. and Mrs. O. Cotton, is an example of this development.

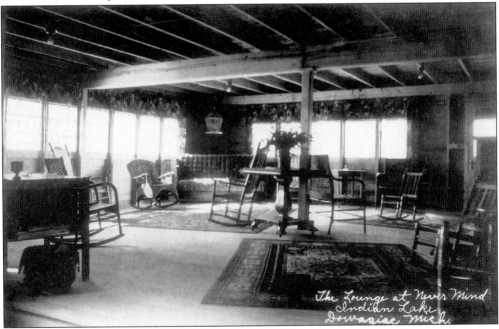

This view is of a section of the lounge at the Never Mind Hotel. Since this area was always a focal point, the owners always tried to make it special. The objective was to make the area rustic, comfortable, and intimate. The rugs, different types of rocking chairs, and birdcage all help to create the atmosphere.

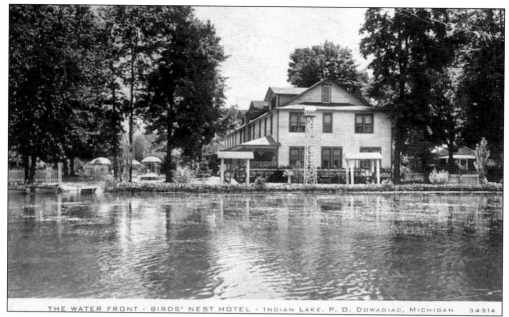

THE WATER FRONT · BIRDS' NEST HOTEL · INDIAN LAKE, P. O. DOWAGIAC, MICHIGAN 34314

This postcard from C. R. Childs Photography Company uses the 34300 through 34399 numbers for Indian Lake. Every resort or hotel tried to have a unique name for its property. This waterfront view shows a large three-story building that was called the Birds Nest Hotel. In earlier years, it was also called the Birds Nest Inn and owned by Mr. and Mrs. E. Hancock.

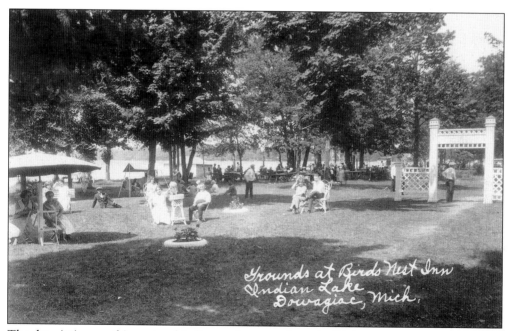

The description on this postcard indicates the grounds at the Birds Nest Inn are shown. One of the attractions of this hotel was this wonderful lawn. This area was between the inn and the Indian Lake shoreline. The hotel was next to the Wiest's Resort complex, and people were free to wander back and forth.

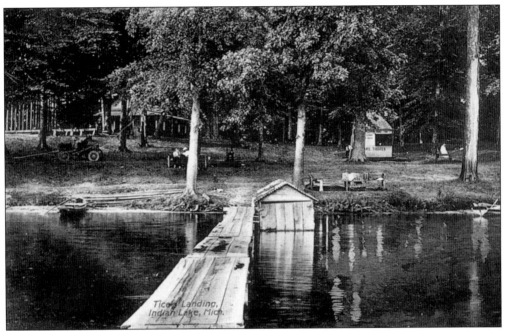

This postcard is not colorized but has been printed in Germany, so it is approximately of 1910 vintage. It shows the early buildings at Tice's Landing at the north end of Indian Lake. This property and its owner, Isaac Tice, are shown in the 1860 plat map of Silver Creek Township. His son, Talmidge, started the resort development. On the left-hand side of the card is a very early automobile.

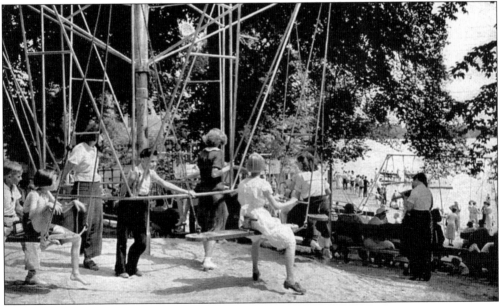

Ralph Tice, the third generation of the family, continued to develop the resort. Tice was a skilled mechanic and machinist who also had a shop in Dowagiac. In the summer, Tice and his brother ran the resort. This photograph showing an elaborate swing system demonstrates his ingenuity and skill.

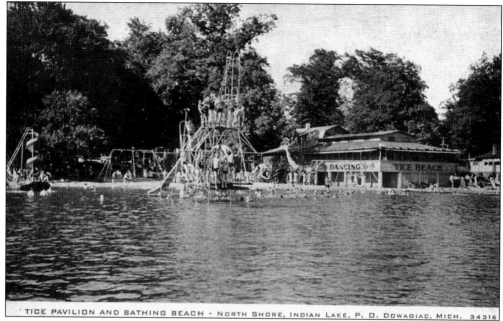

TICE PAVILION AND BATHING BEACH - NORTH SHORE, INDIAN LAKE, P. O. DOWAGIAC, MICH. 34316

A lake view of Tice's dance pavilion and beach is seen here. As was mentioned earlier, Ralph Tice and Earl Wiest Jr., at each end of Indian Lake, were rivals. If one of them built some attraction, the other would try to make it bigger and better. This 1940s scene shows how Tice, with his machine shop, could make different and unique metal structures to play on.

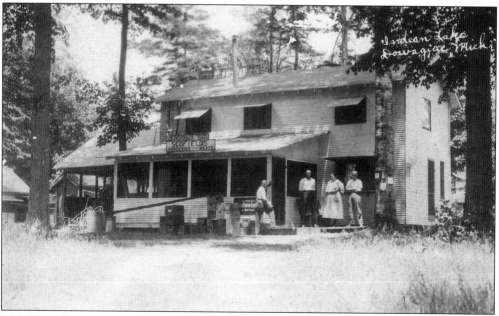

This 1923 photograph is a view of Scofields. The building was a combination home and grocery store owned by Harry and Margaret Scofield. The store was located at the north end of Indian Lake. Since it was one of the few stores in the area, it carried a full range of groceries and was open all year round. The little sign on the building also says they offered lunch every day.

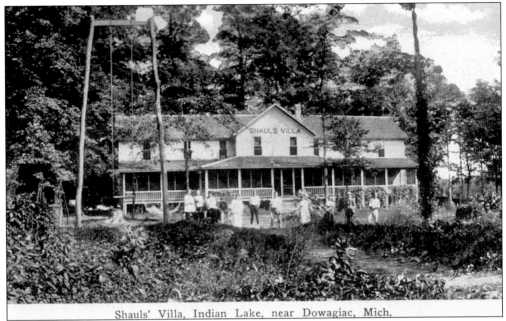

Shauls' Villa, Indian Lake, near Dowagiac, Mich.

The July 3, 1918, postmark on this card is from Cassopolis. The sender of the card talks about picking cherries and playing with the chickens. This resort on Indian Lake wanted to be different so it was named Shaul's Villa. The Silver Creek Township plat map from 1860 shows A. Shaul owning 80 acres. Notice the 20-foot-high wooden frame for the swing.

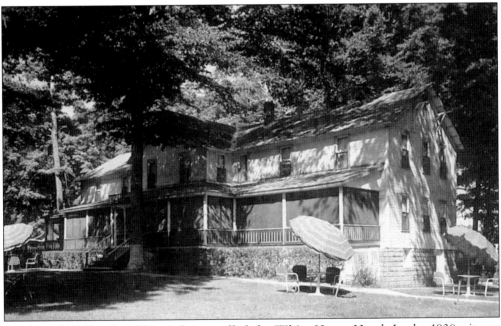

By the 1920s, Shaul's Villa was being called the White House Hotel. In the 1930s, it was used as a residence hall for campers. As shown in this photograph, the resort then became the Kickapoo Lodge. The lodge had a weekly rate of $35 each, which included two seven-course meals a day.

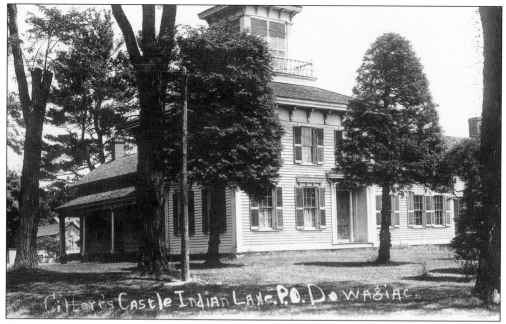

The 1916 photograph is a view of what was called Gilbert's Castle at Indian Lake. It was named for early settler William B. Gilbert, who built the imposing house after coming here in 1839. Because of its size and third-floor cupola, the house quickly acquired the nickname Gilbert's Castle. One of the stories about the cupola was that its purpose was to watch for marauding Native Americans or stagecoaches.

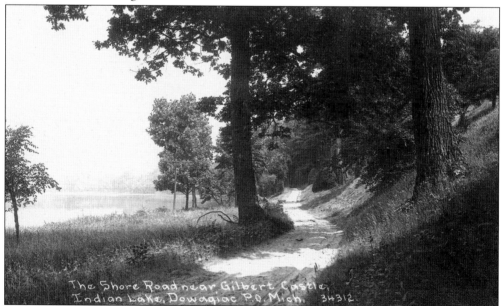

This road is between the farmhouse called Gilbert's Castle and the Indian Lake shoreline. William B. Gilbert and his wife, Cynthia, had six children and had a farm with over 400 acres. He became a very prosperous farmer, was a justice of the peace, and was known affectionately as "Uncle Tommy." After his death in 1864 at age 75, the house was occupied by his son Eugene B. Gilbert.

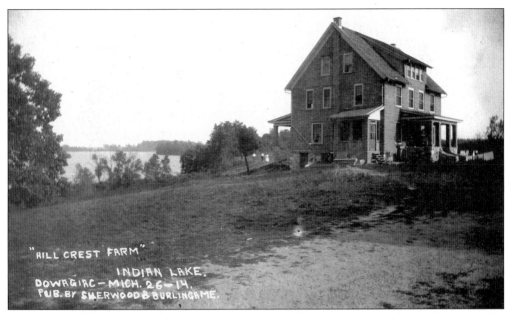

The 1909 postcard identifies this large house as the Hill Crest Farm at Indian Lake. As can be seen in the picture, this farmhouse had a spectacular view of the lake. In 1922, two brothers, Forest and Carl Steimle, bought the farm and developed it into a nine-hole golf course and used the house as a clubhouse.

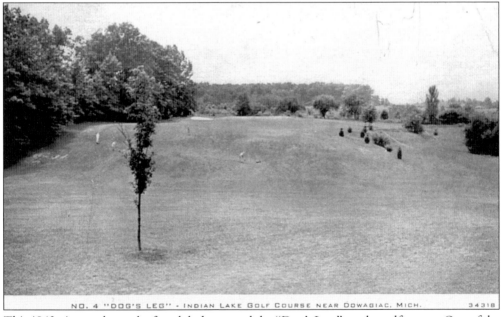

NO. 4 "DOG'S LEG" · INDIAN LAKE GOLF COURSE NEAR DOWAGIAC, MICH. 34318

This 1943 picture shows the fourth hole, named the "Dog's Leg," on the golf course. One of the Steimle brothers' wives, Harriet, used to tell the story about the gangsters who played the course and kept a machine gun in their bag with their golf clubs. Because of the course's popularity with vacationers and local residents, a second set of nine holes was built in 1965.

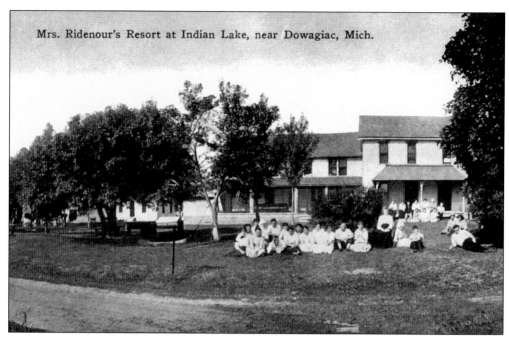

Mrs. Ridenour's Resort at Indian Lake, near Dowagiac, Mich.

This postcard of what was called Mrs. Ridenour's Resort is an example of one of the farms on Indian Lake also becoming a summer resort. At the beginning of the 20th century, the chance to enjoy a farm experience was an added benefit for vacationers. For visitors from Chicago, milking a cow was a once in a lifetime experience.

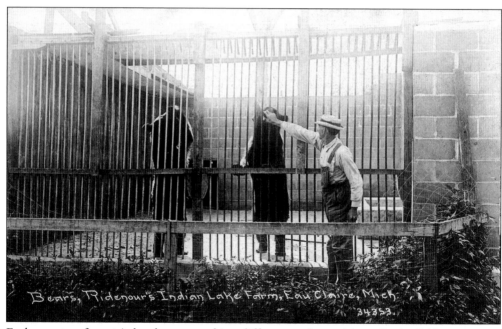

Bears, Ridenour's Indian Lake Farm, Eau Claire, Mich.
34353.

Each resort or farm tried to have something different to draw visitors. In the Ridenours case, they acquired two bears. They then had a large cage made of cement blocks and iron bars built for them. At various times during the day, the resorters came out to see the bears be fed and watch their antics. This photograph shows Henry Ridenour feeding a bear.

Six

MAGICIAN, CABLE, AND PIPESTONE LAKES

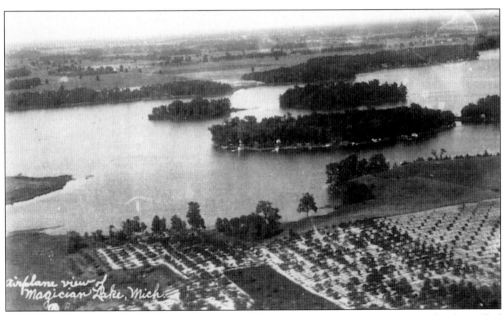

This aerial postcard shows Magician Lake and the three islands in it. The largest island is called Maple Island and is connected to the mainland by a bridge. The smallest island is named Scouts Island. This is to honor the eight Boy Scouts and their leaders who lost their lives in a storm on the lake in 1922 while trying to reach the island. The other island is named Hemlock.

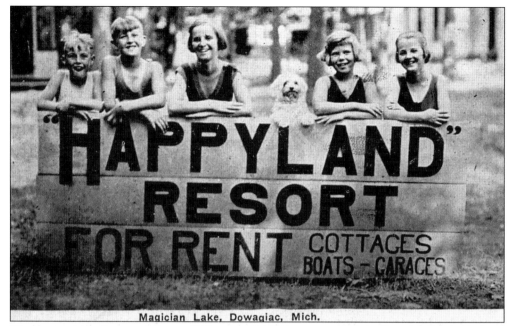

Magician Lake, Dowagiac, Mich.

These young vacationers are from a 1923 postcard. This resort was originally started by Frederic E. Howe. He and his wife had a theatrical troupe that would spend their summers there writing plays and taking them out on the road. These actors would then be available to groups attempting to raise money for special causes.

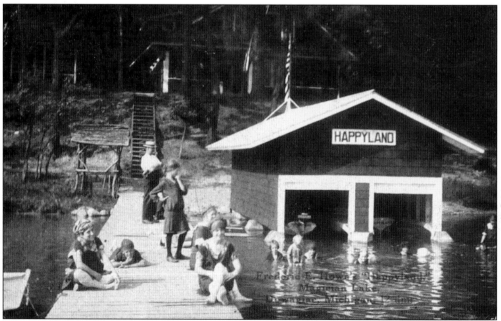

Here is a 1915 view of Happyland Resort taken from the pier. The boathouse has two boats in it, with one having an early outdoor motor mounted on the back. The shape of the boats was to help them glide through the water. The ladies are in their fashionable bathing suits of the time.

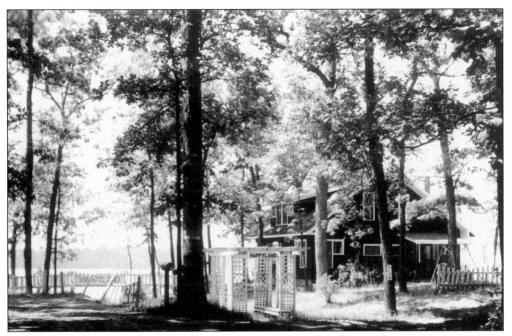

A 1939 street view of the owner's house at Happyland is seen here. At this time, the new owner was Rev. Roderic Murray. He was a Methodist minister in Chicago for 47 years. In the summertime, Reverend Murray, besides running his resort, would often substitute for local ministers. The original cottages at Happyland were built to represent English cottages.

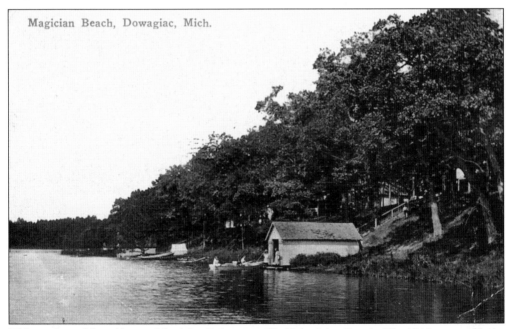

This section of shoreline on Magician Lake was called Magician Beach. The 1914 postcard in its original form is another colorized photograph made in Germany and then sent back. The Magician Beach scene shows the hill and stairs leading down to a boathouse. A boathouse indicated that a more sophisticated boat went with the owner of the cottage. This boathouse is still standing.

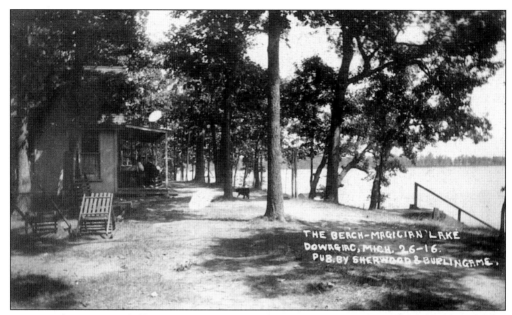

A September 9, 1909, hilltop view shows Magician Beach where some cottages were located. Depending on one's point of view, this could be either a good or bad feature. The hill offered a great view and cooler breezes during those hot summer days. On the other hand, the hill meant a lot of climbing up and down and carrying stuff to the lake on those hot days.

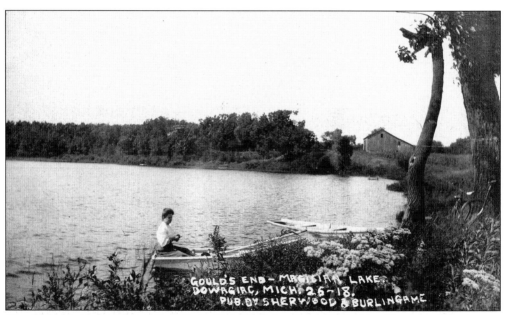

The 1910 photograph is of Gould's End at Magician Lake. This shoreline is on the eastern bay of the lake, and the land was owned by farmer Wil Gould. He had rowboats to rent for vacationers. Leaning against the tree is a bicycle that the female boater arrived on. The barn in the background is on the Cumming's farm, and the wooded shoreline would become part of the Gregory Beach Resort.

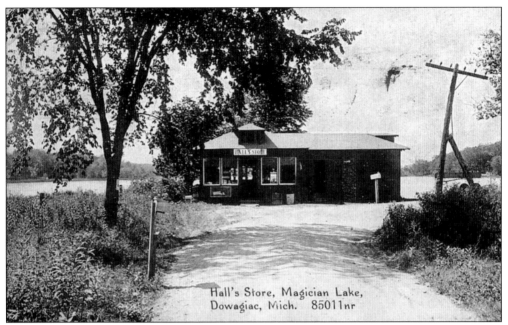

Hall's Store, Magician Lake,
Dowagiac, Mich. 85011nr

The 1929 postcard shows what is now Sixty-second Street leading to Hall's Store. This was a general store only open in the summer months. Because of its location, the store could be reached by land or water. The property changed hands and at some point became known as Dean's Store. Notice the C. R. Childs Photography Company numbering of 85000 for Magician Lake with this postcard being 85011.

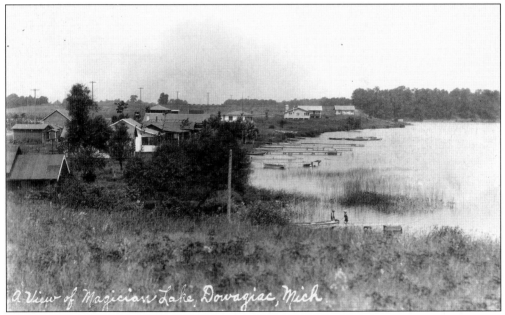

A View of Magician Lake, Dowagiac, Mich.

This view of Magician Lake is of the northeast shoreline. Shown in the 1920s postcard is a group of cottages. This section of lake was shallow at this time, and the piers were built out accordingly. The utility poles in the upper part of the postcard are along the highway. The wooded area in the upper right corner of the postcard is the location of a current public access.

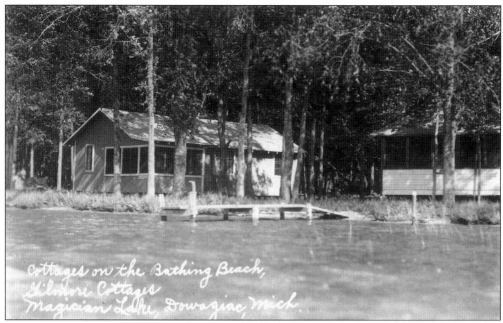

Cottages on the Bathing Beach, Gilmore Cottages Magician Lake, Dowagiac, Mich.

The 1929 photograph shows a group of cottages on the southeast side of Magician Lake. These were across the bay from the Gregory Beach Resort. These cottages were owned and operated by R. C. Gilmore. The property consisted of 25 acres and had 20 cottages. Gilmore operated this resort from 1909 to 1939. His two daughters, Marjorie and Marian, would spend their summers helping their father run the resort.

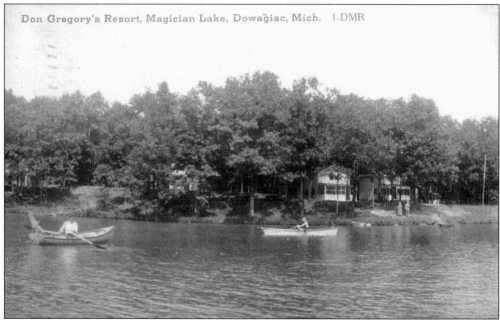

Don Gregory's Resort, Magician Lake, Dowagiac, Mich. I-DMR

This 1916 view shows Don Gregory's resort on Magician Lake. The resort started with 3 cottages, which evolved into 22 cottages. Generations continue to return to the same cottages. In fact, one family has been coming for the last 64 years. Notice a couple standing at the shoreline on the right side of the card. This man and woman are Don and Nell Gregory, founders of the resort.

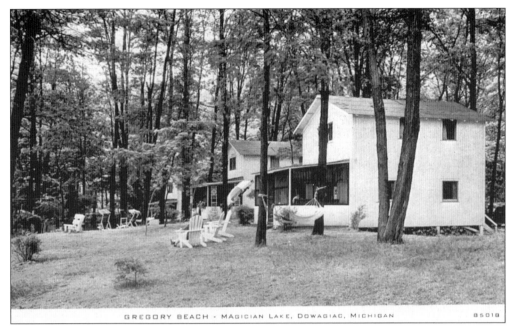

This view of Gregory Beach shows three of the two-story cottages. These buildings were at the east end of the Gregory property. There are two unique features about their construction. First, they were built off the ground to make them less susceptible to termites. Second, they were built of two store-length vertical boards so that there is no internal stud structure holding them up.

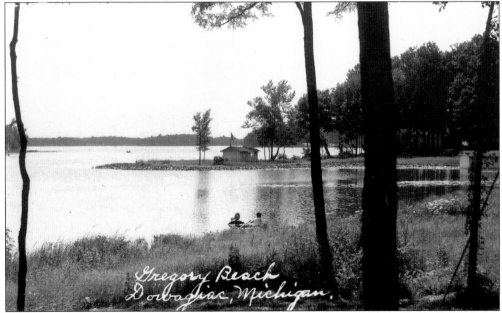

This 1938 view of Gregory Beach is of a natural point along the shoreline. The building shown on this point was called the Piano House. This structure was a combination storage room and recreation area for the children. Don Gregory had an upright piano installed for the guests' entertainment. A piano in that room became a fixture in years to come, thus the name Piano House was attributed to the building.

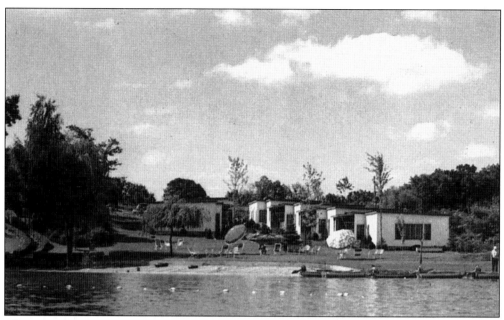

This 1960s postcard is of Tuverson's Resort on Magician Lake. At one time, there reportedly were 14 resorts or cottage complexes on Magician Lake. This resort had self-contained units with electric kitchens and heating units. Their rates were $45 to $65 per week, and no pets were allowed. This complex is still operating, although now as a condominium complex.

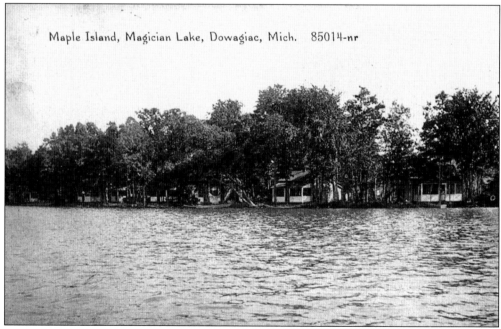

Maple Island, Magician Lake, Dowagiac, Mich. 85014-nr

This postcard is an example of a mistake by either the photographer or the C. R. Childs Photography Company back in Chicago. The photograph is not of Maple Island but rather some other cottages along Magician Lake shoreline. The postcard even has the numbering system that was used for the Magician Lake series. There are postcard collectors that just collect mistakes.

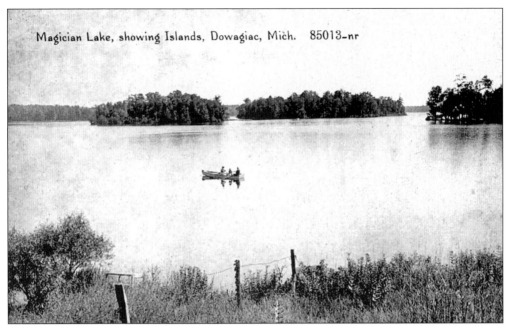

Magician Lake, showing Islands, Dowagiac, Mich. 85013-nr

Shown in this view are two of Magician Lake's islands and a portion of the third island called Gardners Point. The first gentleman to buy these islands and a part of Magician Lake was Luther Guideau Jr. from New York State in the mid-1830s. Based on land selling for $1.25 an acre and the size of the three islands, these cost Guideau a grand total of $33.

The bridge from 1914 is shown is this photograph; it connected Maple Island to the mainland. What cannot be seen in the picture are the four large metal barrels filled with concrete that held up the wooden bridge. Before the bridge was built, some of the materials and whole cottages were brought over to the island on the ice during wintertime.

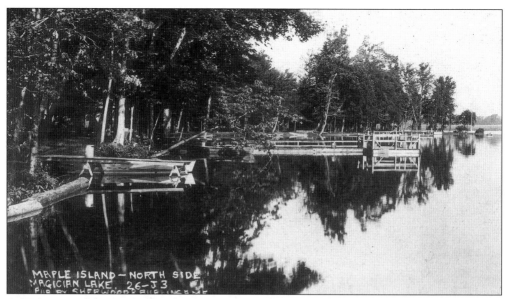

A 1910 view of the north side of Maple Island shows some of the cottages' piers. In 1895, nine Dowagiac businessmen formed an association to purchase Maple Island for their private resort. They bought the island from Bartholomew and Meemy Jones for $700. They subsequently purchased from Patrick Curran, for $300, a right-of-way to the island and a strip of land along the mainland.

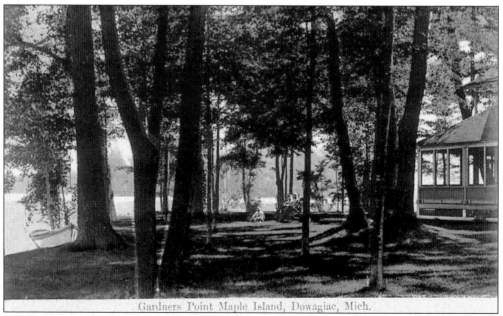

Gardners Point Maple Island, Dowagiac, Mich.

A 1910 view shows Gardners Point on Maple Island. It was named this because Archie B. Gardner and his wife, Amanda, had bought these lots for their summer cottage. Gardner was one of the original businessmen from Dowagiac and was a grandson of Philo D. Beckwith, founder of the Round Oak Stove Company. The original cottage was constructed in 1898 and has since been remodeled and relocated at that site.

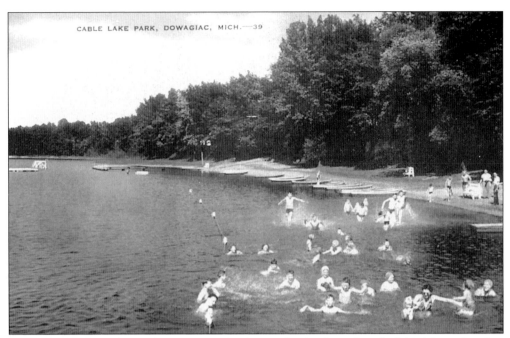

CABLE LAKE PARK, DOWAGIAC, MICH.—39

This *c.* 1940s postcard of Cable Lake is the only one that has been found of this lake so far. One of the reasons for this lack of postcards is there were no resorts around it nor is there a public access. The children in this scene are at the E. Root Fitch Camp on Cable Lake. These children are third through sixth graders from the Dowagiac School System.

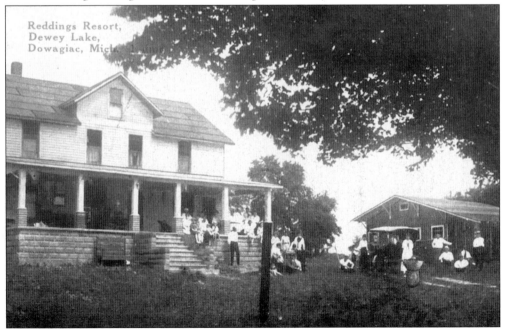

Reddings Resort,
Dewey Lake,
Dowagiac, Mich.

Even though this postcard says Dewey Lake, the Redding Resort was a farm that bordered both Dewey and Cable Lakes. E. Root Fitch from Dowagiac had inherited over $3 million. In 1941, Fitch and his wife purchased the Redding Resort and turned it into a summer camp for Dowagiac schoolchildren, requiring only a nominal fee. The camp is still in operation.

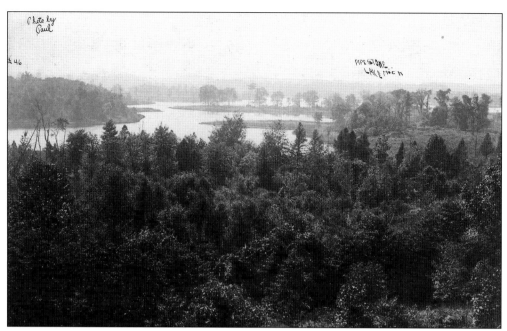

This postcard is one of only a few that have been found of Pipestone Lake. This 1920s view was taken from the kitchen window of a farmhouse by the Sister Lakes photographer Paul Frank. This 119-acre lake is in Bainbridge Township, just off Napier or Meadowbrook Roads. The angle of the photograph is looking at the southwest corner of Pipestone Lake.

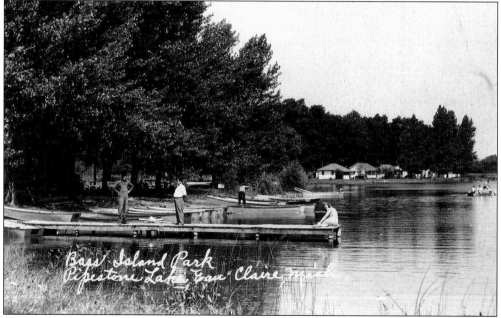

This 1950s postcard shows a portion of the public access and park at Pipestone Lake. The park is named for one of the two little islands in the lake. In the background of the photograph, Pradun's Bass Island Park Resort cottages can be seen. The one island can be reached by a walkway. This part of the shoreline was a site that housed a tavern, grill, and dance floor known for its lively weekends.

Seven

Businesses

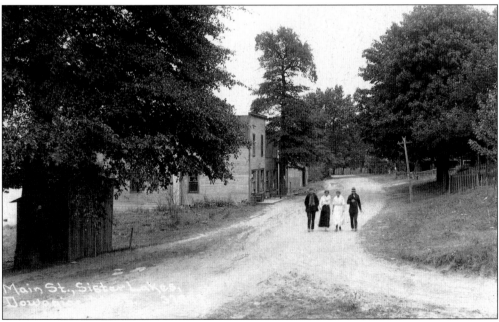

This photograph is a very early view of the main street of Sister Lakes or what eventually would be called Country Road 690. Using other C. R. Childs Photography Company postcards from this period, the date of the scene is approximately 1908. At this time, the business section of Sister Lakes consisted of two buildings at this location. The two couples walking down the dirt road have probably been to one of the stores.

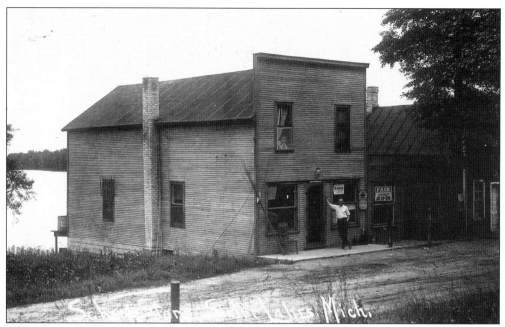

The photograph identifies this building as Schau's store. The store was located along the shoreline of Round Lake. The gentleman leaning against the door is probably the owner. A woman looks out the second-story window on the left side. This second-story area was the living quarters for the proprietor. In the front corner of the store are a bunch of bamboo fishing poles for sale.

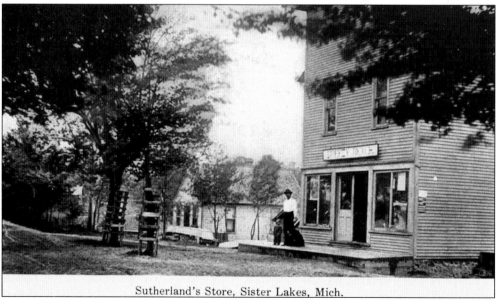

Sutherland's Store, Sister Lakes, Mich.

A 1909 postcard shows the recently built Sutherland's Store. This building was at the opposite end of Main Street from Schau's store. The proud owner, his son, and his dog stand on the sidewalk for the photograph. The wooden structures around the trees were to protect them from horses eating the bark.

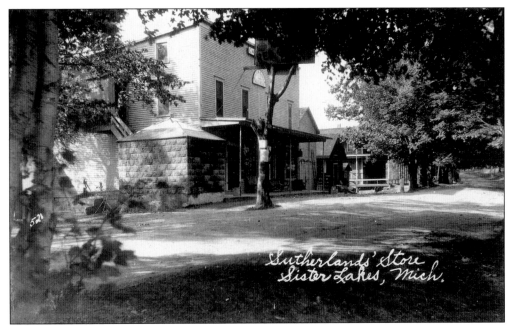

This photograph of Charles W. Sutherland's store was probably taken 20 years after the building was first constructed. The tree in front of the store did not make it and now functions as a utility pole. Sutherland came from a farm family that had been in the area for many years. An 1873 Keeler Township plat map shows the Sutherland family owning 144 acres.

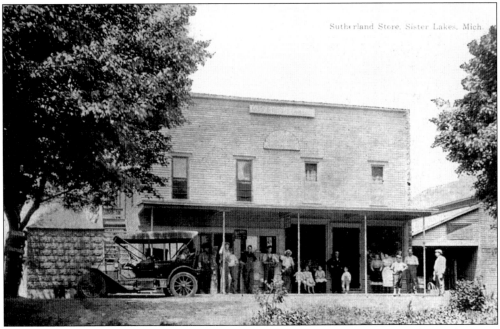

By the time this photograph was taken, Sutherland's Store had doubled in size. The combination of location, Sutherland's business sense, and growing tourist trade made it a very successful enterprise. On this particular day, everyone at the store came out to be included in the picture. The automobile in front of the store was probably owned by Sutherland.

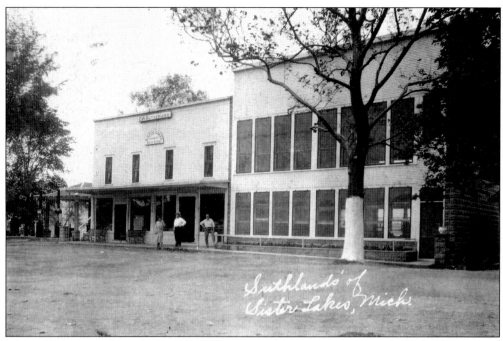

In this 1923 postcard, another building has been built next to Charles W. Sutherland's store. By this time, the store had become one of the focal points of the three lakes (Round, Big Crooked, and Little Crooked). It was the Sister Lakes post office, grocery store, and hardware store all in one building. Trying to capitalize on this popularity, Sutherland built the two-story dance hall.

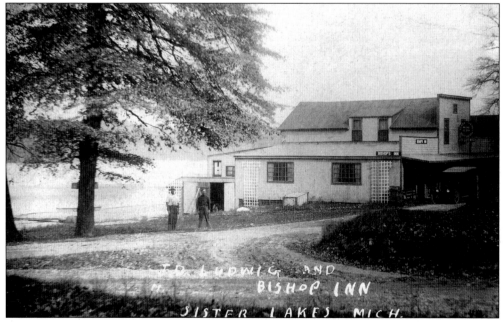

This photograph is a 1922 view of that Main Street corner, or what is now the corner of Ninety-fifth Avenue and Country Road 690. The two buildings, with Round Lake in the background, are the restaurant called Bishop's Inn and J. D. Ludwig's two-story general store. Marie Ludwig sent this postcard to a friend in Detroit.

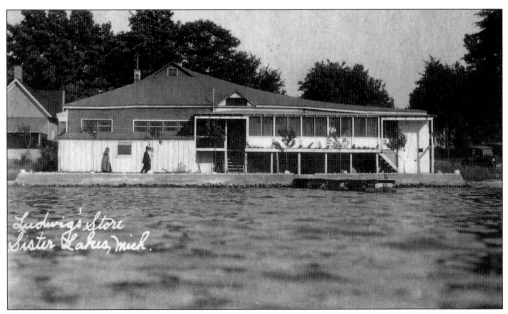

As this 1928 Round Lake view shows, Bishop's Inn and the J. D. Ludwig Store have expanded. This type of configuration became the norm as businesses grew along with the growing amount of resorters. Enclosed porches with screens were added overlooking the water, and a pier access was always included in the expansion.

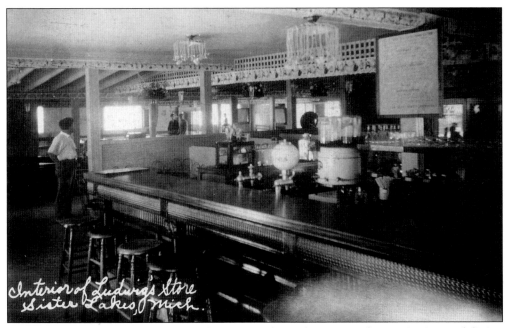

This interior view of the expanded Ludwig's store shows the variety of entertainment and dining options that were available to the vacationers. This old-fashioned mahogany bar was the site of good food and drinks. On the upper right is a sign with the daily specials written on it. The two men in the background are ready to play pool.

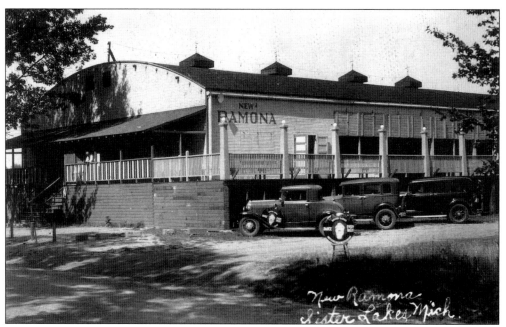

The Ramona Dance Pavilion was built by two brothers, Charles and Harry Adams. The grand opening of this pavilion was timed for July 3, 1928. The dance hall became one of the premium attractions for the whole Sister Lakes and surrounding area. On any given summer night, this was the place to be.

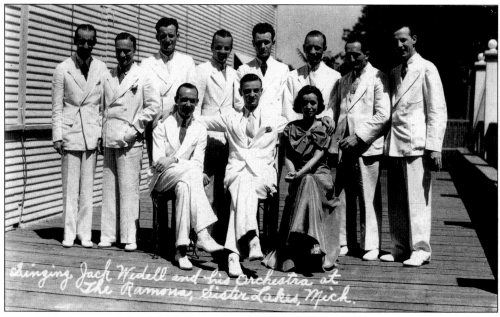

This 1935 photograph is of "Singing Jack" Widell and his orchestra at the Ramona Dance Pavilion. Each weekend during the summer, every band would sit for its photograph. These traveling bands had a circuit they played all over the Midwest. By the 1930s, most of these bands would also have a female vocalist.

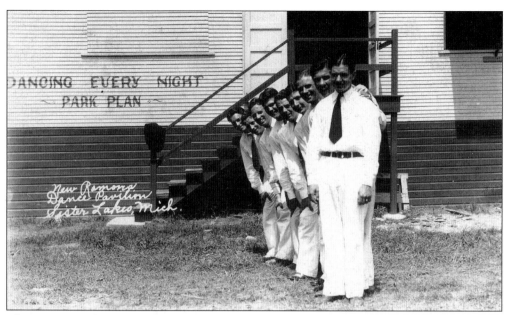

This is a 1928 photograph of one of the bands at the Ramona Dance Pavilion. These young musicians, in their all-white attire, are seen posing for their photograph during their weekend to entertain. These bands could always look forward to a very receptive and lively crowd. Many a night, there was a line waiting to get in.

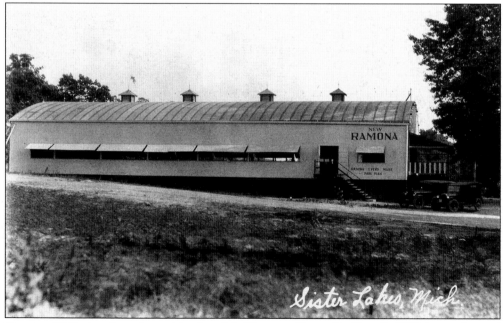

Here is a 1928 view from the parking lot of the Ramona Dance Pavilion. In 1958, it was changed to a roller-skating rink. The current owner, Harold Schaus, worked there as a young man and always wanted to own it. He and his family continue to make the Ramona Dance Pavilion a traditional place to play at Sister Lakes.

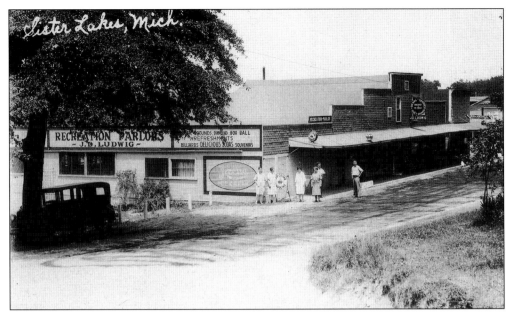

Another 1928 view of J. D. Ludwig's building, taken from the road, is seen in this image. This photograph probably shows the owner and all his help posing for their picture. As can be seen by the sign, the building is now being called the Recreation Parlors. On the overhang roof are two emblems for gasoline. At the right corner of the building, Milo Decker's Barber Shop can be seen.

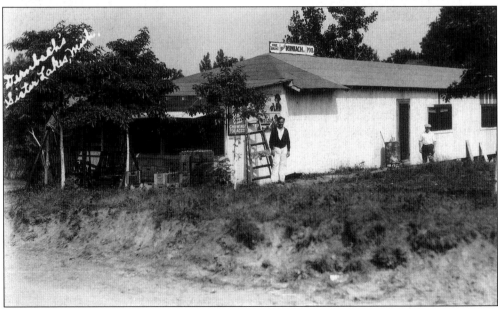

This 1920s postcard shows one of the new businesses at Sister Lakes. This dance and pool hall was owned and operated by a Mr. Dernbach. In front of the building stands the owner. Notice the large advertisement on the building for chewing tobacco. Many of this type of business were only opened during the summer months, and many of them only had seasonal liquor licenses.

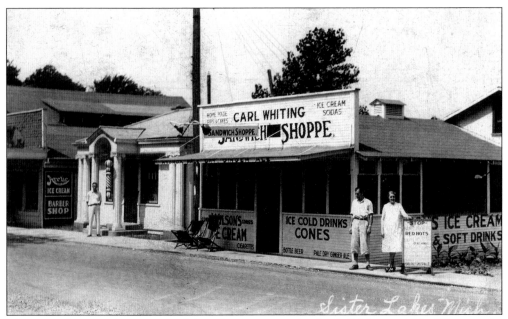

The 1931 photograph is a view of three businesses on the "strip." The partial building on the left-hand side of the photograph is Bishop's Inn. This eventually burned down and was later called the Legacy. Milo Decker is standing in front of his barbershop. Owners Carl Whiting and his wife stand in front of their sandwich shop.

Carl Whiting's sandwich shop in this photograph had been moved 400 feet north of its original site and remodeled. As can be seen in the card, a screened-in porch for dining has been added to overlook Round Lake. One of the signs indicates that breakfast was one of its specialties. One can assume the gentleman standing along the building is Carl Whiting.

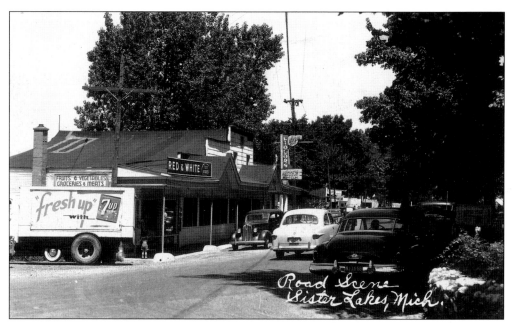

This early-1950s photograph is from the corner of Ninety-fifth Avenue and the road called Country Road 690. What used to be J. D. Ludwig's store is now the Red and White Grocery Store. This store was operated by two brothers from Coloma, Bob and Chuck Reinhardt. They also had a Red and White Grocery Store in Coloma. The other side of this building was still the restaurant called Bishop's Inn.

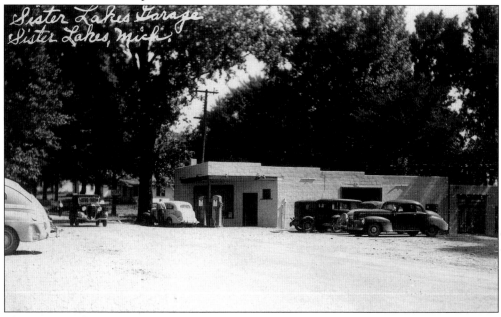

This scene is of Don Hogmire's combination gas station and garage operated by Hogmire and his son. This structure was on the corner of Victory Shore Lane and Country Road 690. This represents a full-service filling station of the time, which meant that one would have a person fill their tank, wash their windows, and check their oil and their tire pressure. It also had a couple bays in the garage for automobile repair.

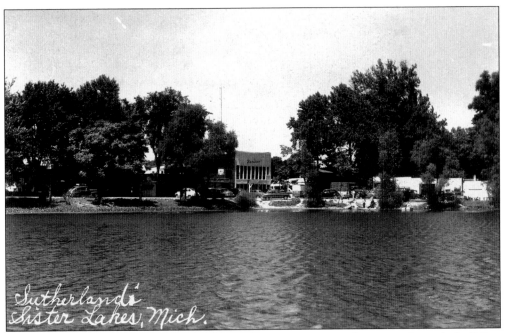

This view was taken from Big Crooked Lake. The description on the postcard says the building in the background is Charles W. Sutherland's store. In fact, by this time, the two-story building is the Sanbar Tavern. On the right-hand side of the postcard is Hogmire's filling station and garage. Here was a gas pump for boats and a boat ramp.

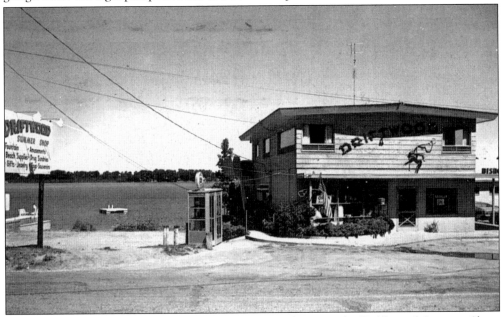

This 1974 photograph is of the very popular teenage hangout the Driftwood Summer Shop. Carl and Lucille Timmons built this building in 1948 as a gift shop and had an old-fashioned soda fountain. The structure was originally a one-story building with a second story added later. During a summer night, the telephone booth shown always had a line waiting to make a call. (Courtesy of Penrod-Hiawatha Company.)

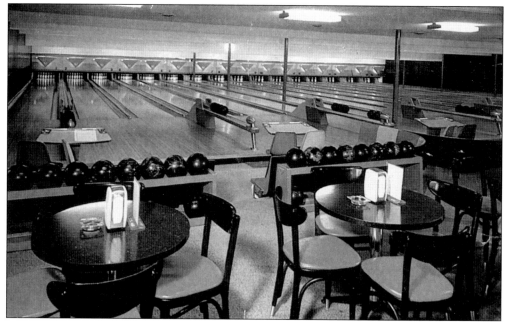

The 1960s postcard is an interior view of Lakes Bowl. The owners, Roy and Wilma Gulliver, started with eight lanes in 1959 but soon added another eight lanes. The building also had a fine dining room with large windows overlooking Round Lake. This location had been the original Grange hall, Gleaner Hall, and Little Giant Roller Skating Rink. (Courtesy of Penrod-Hiawatha Company.)

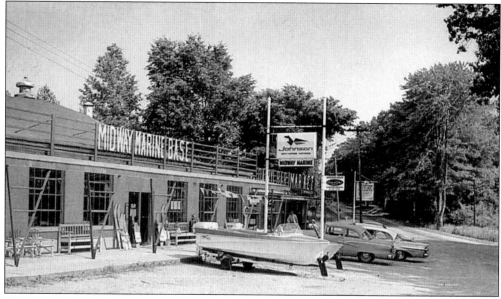

This early-1960s postcard shows Midway Marine Base on M-152 between Magician and Dewey Lakes. At this time, the buildings were a combination of boat and motor sales, grocery store, restaurant, and dairy bar. The original building, built in 1930 as a dance hall, was the largest freestanding structure in Cass County. During the 1930s and 1940s, it was the White Elephant and Melody Gardens Dance Hall. (Courtesy of Penrod-Hiawatha Company.)

Eight

SURROUNDING CITIES AND VILLAGES

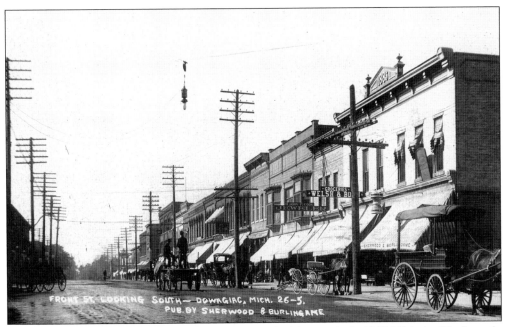

This 1909 photograph shows Dowagiac's Front Street looking south. In 1847, Nicholas Chesbrough, a right-of-way buyer for the Michigan Central Railroad, and Jacob Beeson bought 80 acres from Patrick Hamilton and first platted the village in 1848, naming it after the river. The 2000 United States census for Dowagiac was 6,147 people.

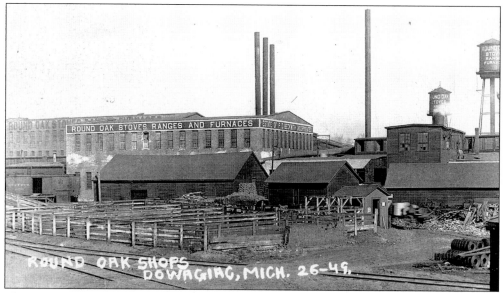

This 1911 photograph is a view of part of the massive Round Oak Stove Company. Philo D. Beckwith built a stove to heat his foundry around 1865. An official from the Michigan Central Railroad saw it and ordered one for the Niles depot. Soon hundreds of orders for the stove started arriving, and Dowagiac had a new industry. By 1929, four other furnace companies gave Dowagiac the nickname of "Furnace City of America."

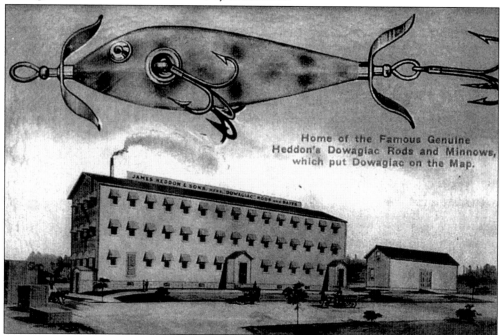

This postcard from around 1912 shows the factory of James Heddon and Sons in Dowagiac. It is also an advertisement for a famous fishing lure. This first building of the company was erected in 1910 and made bait-casting rods and artificial minnows. By 1950, Heddon was one of the biggest lure companies in the world. At that time, the company was making 12,000 to 15,000 lures a day.

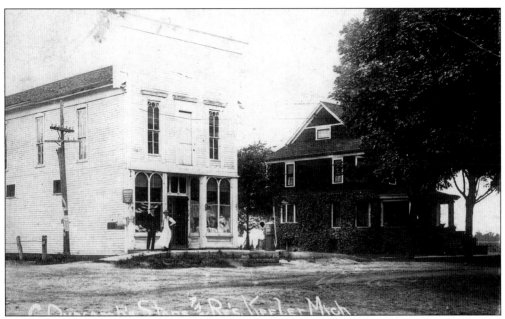

This 1917 photograph was taken in the village of Keeler. It shows Charles Duncombe's store and the family residence next to it. The Duncombes were one of the earlier families that settled in this area. The village and township are named for Wolcott H. Keeler, who came in 1835 from Vermont. He bought a total of 480 acres from the United States government.

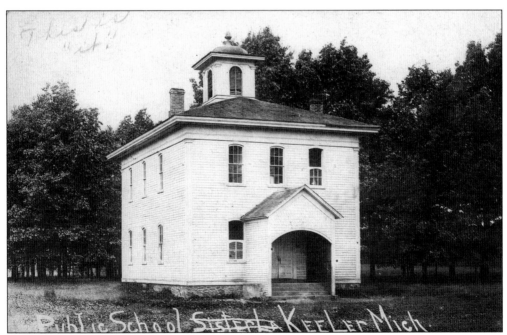

The two-story wooden building in this 1914 postcard is the Keeler Public School. It was erected in 1875 and housed students from 1st grade through 11th grade. In January 1930, while school was in session, smoke was observed coming through the floorboards. All the students were evacuated safely, but the school burned down.

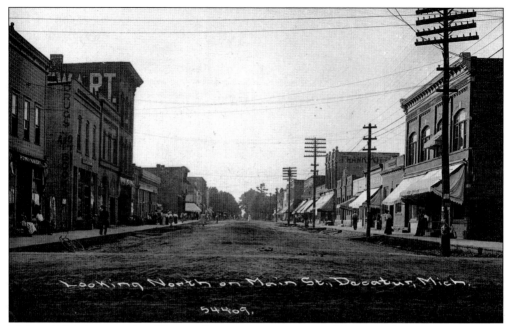

This *c.* 1905 photograph of Decatur's Main Street is unusual because there are no buggies, wagons, or horses on the street. Decatur was founded in 1847 by Joseph D. Beers and Samuel Sherwood when they donated land for a railroad depot. The 2000 United States census for Decatur was 1,838 people.

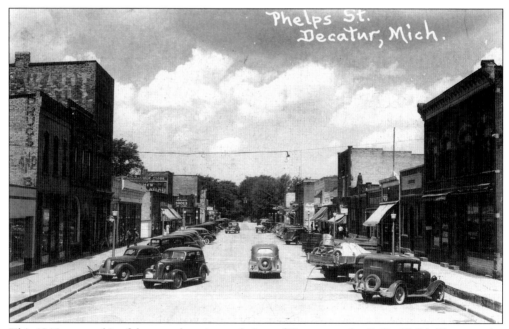

This 1945 postcard is of the same location and view of Decatur as the C. R. Childs Photography Company 1905 photograph above. This street is also called Phelps Street. The most obvious change is the paved road and automobiles. Some of the businesses and owners have changed, but the buildings are the same.

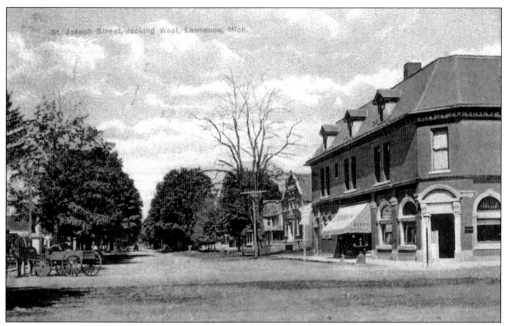

This 1911 postcard shows downtown Lawrence looking west on St. Joseph Street, now known as Red Arrow Highway. Lawrence was founded in 1835 by John Allen, who named it Mason after Gov. Stevens T. Mason. John R. Baker platted the village and renamed it Lawrence in 1844. The 2000 United States census for Lawrence was 1,059 people.

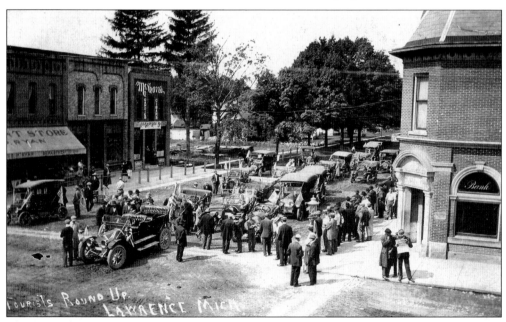

This 1912 photograph is a view of the intersection in downtown Lawrence. The bank and its doorway are in the two-story building on the right side of the card. Every automobile in the area must have come to Lawrence for this day. The event was probably a Fourth of July parade, because each automobile has American flags attached. For the time period, this was quite a gathering of vehicles.

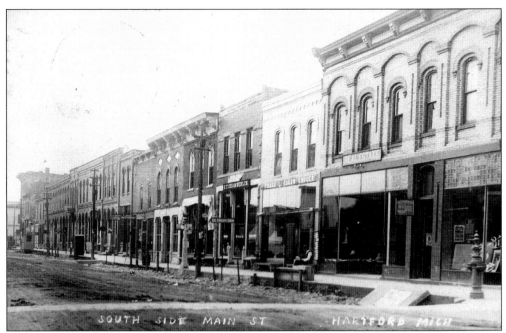

A view of downtown Hartford's Main Street looks south in a 1909 postcard. In 1837, the village was first called Hartland, but by 1840, the name was changed to Hartford. It was first platted by Truman Stratton and W. W. Shepard in 1859. The 2000 United States census for Hartford was 2,476.

This view from across Main Street is of the Hartford House. The original three-story building was built in 1869. When the Chicago and West Michigan Railroad came through Hartford in 1871, the hotel became one of the places to stay. In later years, the hotel became known for its dining room. The building was destroyed by fire in 2004.

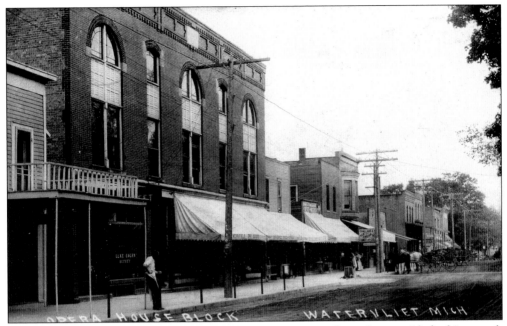

This 1910 postcard is of downtown Watervliet's Main Street from the east side looking south toward the railroad tracks. Watervliet began in 1833 when Sumner and Wheeler built a sawmill on the Paw Paw River. Jesse Smith and E. C. Merrick platted the village in 1838. The 2000 United States census for Watervliet was 1,843.

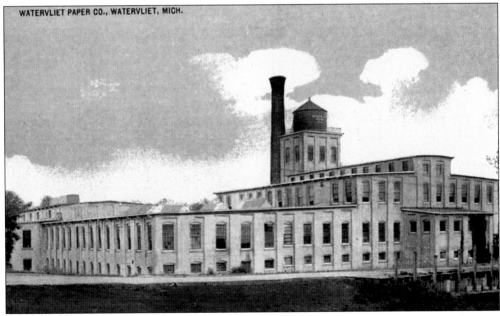

A 1914 view shows the Watervliet Paper Mill. The original 1893 building was erected on the same site as the old sawmill. By the late 1920s, with new buildings and equipment, the paper mill had a reputation of making some of the finest coated printing paper in the country. The mill eventually closed and the buildings town down with the property now ready for redevelopment.

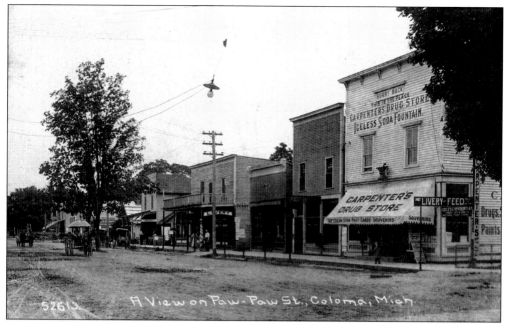

This 1911 C. R. Childs Photography Company photograph of Coloma shows a south view of Main Street looking at the west side of the street. The first house built here in 1834 was by Stephen R. Gilson. After coming back from the California Gold Rush, Gilson platted the village in 1855 and had its name changed from Dickerville to Coloma. The 2000 United States census for Coloma was 1,595.

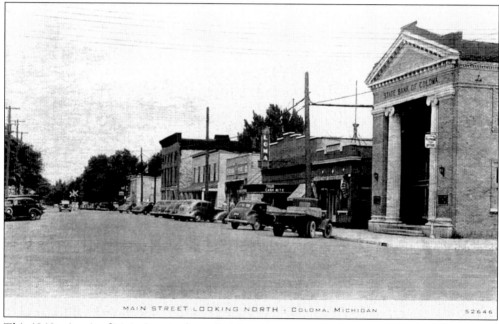

This 1940s view is of Main Street, also called Paw Paw Street, looking north toward the railroad tracks. The buildings on the right side of the street are, from front to back, the State Bank of Coloma, United States post office, Loma Movie Theater, Kolberg's Grocery Store, Pitcher Hotel, and Michigan Shore Lumber Company.

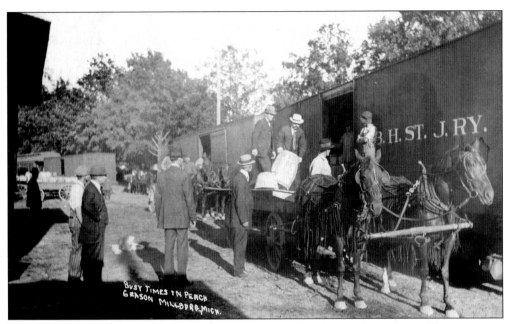

The 1914 photograph shows barrels of peaches being loaded onto the train. Millburg was one of the stops on the interurban route from Benton Harbor to Paw Paw Lake. Besides passengers, the train was also used to ship freight. Millburg was platted by Jehiel Enos and Amos S. Amsden in 1835. The name was chosen by Enos because he and his brother Ira had built a mill on the nearby creek.

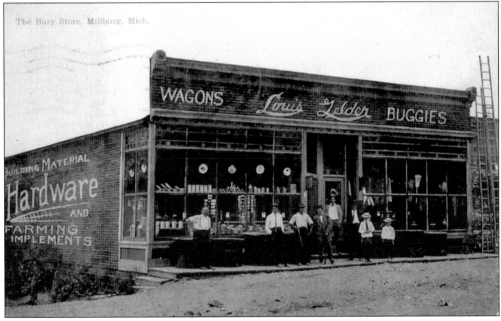

A 1915 view shows Louis Gelder's store in Millburg. As can be seen by the signs painted on the building, this store catered to the farmers in the area. All the larger towns were at least half a day's wagon ride or more away. Thus, stores in the smaller villages such as this one tried to stock a little bit of everything.

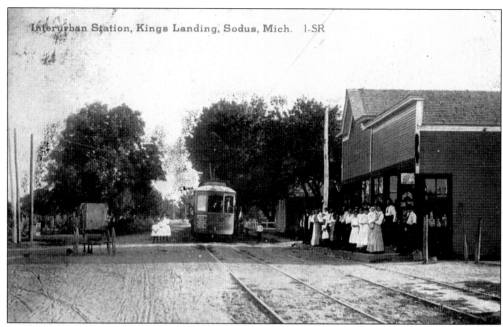

This is a 1917 scene of the interurban train stopping in Sodus. William H. and David Rector were the first permanent settlers here in 1835. In 1859, Sodus became a separate township, and David named it after his native town in New York. The village took the same name when given a post office in 1860.

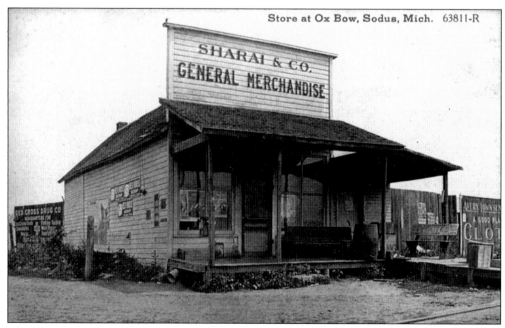

The name Oxbow is from a bend in the nearby St. Joseph River. This general store in Sodus was owned by Luke Sharai, who came with his family as an eight-year-old in 1828. Many of these early settlers worked both the river and land. By adulthood, Sharai was a farmer and businessman. Local folklore claims he became the richest man in the county.

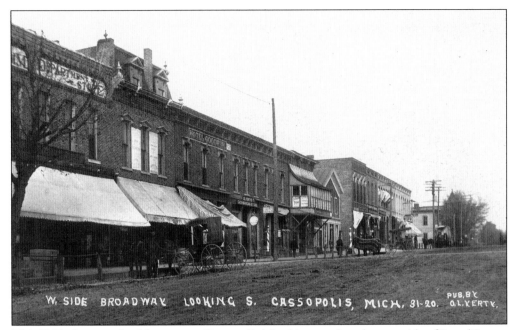

This 1909 photograph of downtown Cassopolis is looking south at the west side of Broad Street. The two-story building in the middle of the block is the Hotel Goodwin. Cassopolis was platted in 1831 by Elias B. Sherman, Alexander H. Redfield, Abram Tietsort, Oliver Johnson, and Ephraim McCleary. The 2000 United States census for Cassopolis was 1,740.

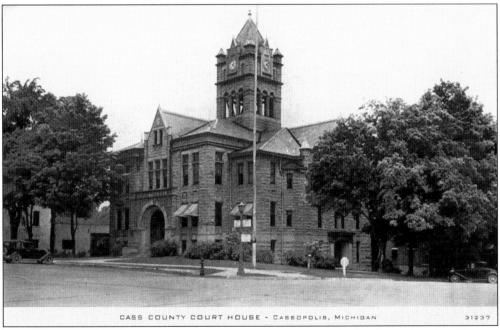

The 1930s postcard is a view of the Cass County Courthouse, which is located in the village of Cassopolis. In 1829, both the county and county seat were organized by the Michigan legislature. The village of Cassopolis was chosen as the county seat. The limestone veneer courthouse was built in 1899 and still functions as the courthouse.

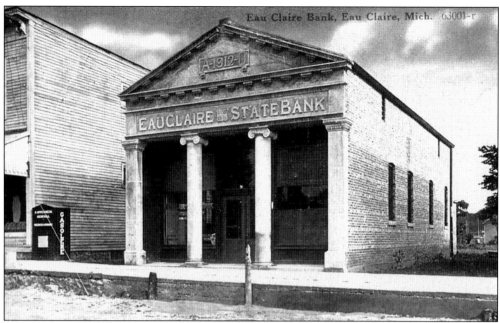

The 1921 postcard is a view of the very imposing Eau Claire State Bank on Main Street. The bank president and owner, Harry Hogue, was known for his integrity, and many deals were sealed with only a handshake. In 1861, farmer William Smyth and R. J. Tulle applied for a post office that was named for a nearby creek. The 2000 United States census for Eau Claire was 656.

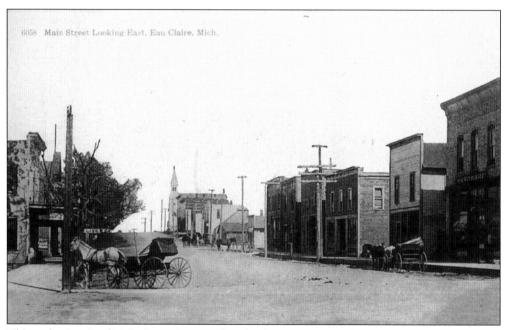

This early view is of Main Street in Eau Claire looking east. One of the ways to approximate the date of these photographs is the means of transportation seen in the picture. The middle of this street divides Eau Claire into two townships, these being Pipestone and Berrien. The steepled building at the end of the street was known as the "Church on the Hill."

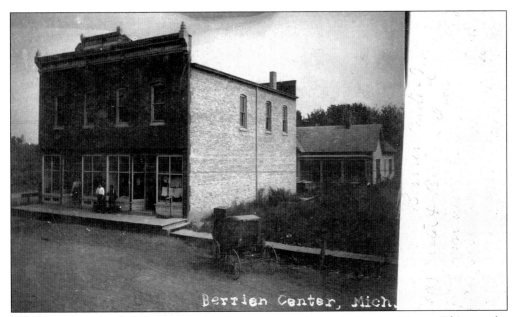

The 1909 photograph shows the brick two-story general store in Berrien Center. This was the Rutter and Willitt building, and it still stands at the corner of Deans Hill Road and M-140. The village was named after the township, which had been named after the county, which had in turn been named after John M. Berrien, attorney general under Pres. Andrew Jackson.

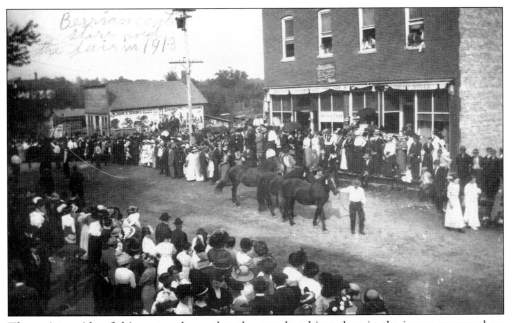

The written side of this postcard says that the parade taking place in the image occurred on November 14, 1913. Berrien Center was hosting a fair that day, and it looks like everyone in the area turned out for the event. In 1900, the village had a general store, depot, telegraph office, freight house, grain elevator, coal yard, and small hotel.

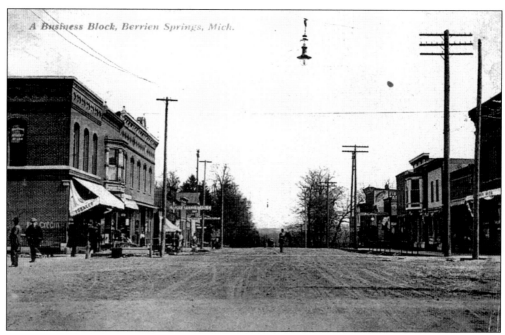

This 1915 postcard shows downtown Berrien Springs looking toward the St. Joseph River. The village was first called Wolf's Prairie before being renamed Berrien Springs because of the many natural springs in the area. It was platted by Samuel Marrs for Pitt Brown, Horace Godfrey, and Francis B. Murdock in 1831. It also became the county seat in 1837. The 2000 United States census of Berrien Springs was 1,862.

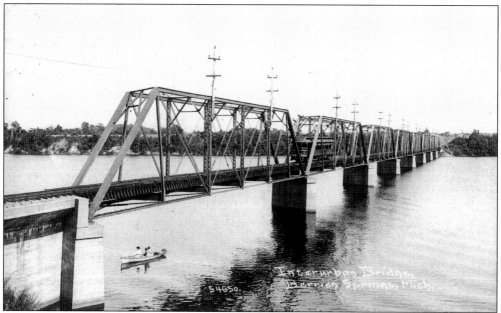

The interurban bridge over the St. Joseph River was the longest bridge in the United States built for an electric railroad. This line ran from South Bend, Indiana, to St. Joseph, and one of its stops was in Berrien Springs. The train shown in the postcard is crossing a part of the river that is called Lake Chapin, which was created by a dam upstream.

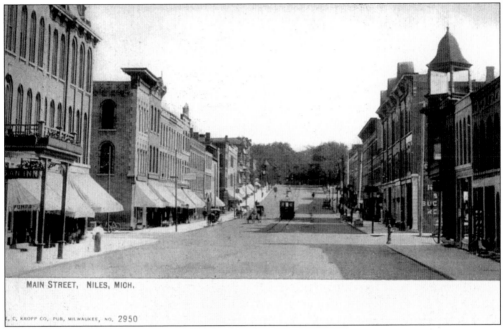

This street scene is of the main street of Niles looking up the hill from the river. A permanent settlement at this site began in 1828 when Eli P. Bunnell and Abram Tietsort built cabins here. Obed P. Lacey platted the village in 1829. The 2000 United States census of Niles was 12,204.

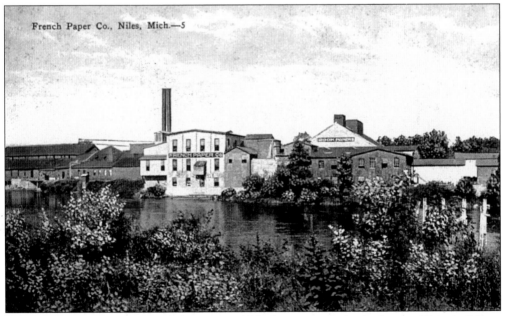

The French Paper Company in Niles was one of the largest employers in the city. These buildings were located on the St. Joseph River. This area was the site of the original French fort. In 1697, a French military post was established here. The British took over in 1761, then the Spanish in 1780, and finally the Americans. Niles is the only community in Michigan to be under four flags.

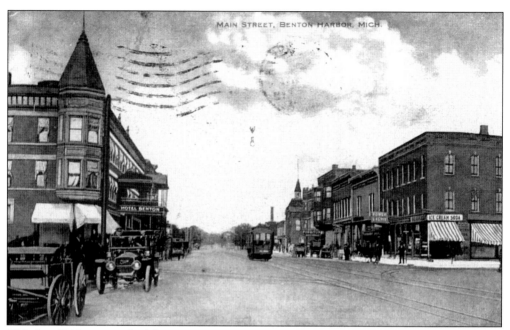

This is a 1910 postcard of downtown Benton Harbor. In 1860, Sterne Brunson, Henry C. Morton, and Charles Hull developed the site by having a canal built from it to the harbor. They then platted the village in 1863. First named Brunson Harbor, it was renamed for Thomas Hart Benton, a Missouri senator who fostered Michigan's statehood. The 2000 United States census for Benton Harbor was 11,182.

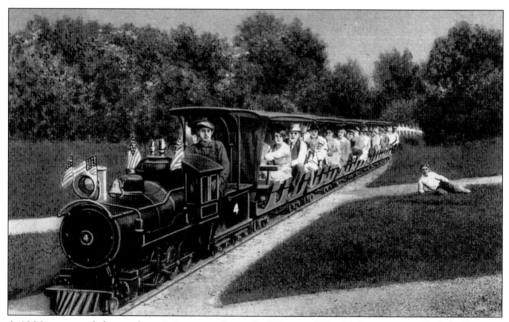

A 1930s postcard shows the miniature train at the House of David Amusement Park in Benton Harbor. This amusement park was owned and operated by a religious colony. It first came to Benton Harbor in 1903 and within a few years numbered over 700 members. Between its amusement park and its long-haired and bearded touring baseball team, it became nationally known.

Saint Joseph, Mich. Landing and Railway Bridge.

This 1906 postcard shows one of the many passenger ships arriving in St. Joseph from Chicago. It would be full of people ready to spend the day or weeks on their Michigan vacation. Calvin Britain settled here in 1829 and, in 1831, platted the village. Previously in 1679, the French explorer René-Robert Cavelier, Sieur de La Salle, had built Fort Miami at this site. The 2000 United States census for St. Joseph was 8,789.

SILVER BEACH, THE PLAY-GROUND OF ALL THE PEOPLE.

The 1908 photograph is a view of Silver Beach Amusement Park. Each year, as it grew more popular, the owners, Logan J. Drake and Louis D. Wallace, would add more attractions. From its Shadowland Ballroom to its roller coaster, the park and Lake Michigan waterfront had entertainment for all. After generations of fun, Silver Beach closed in 1970.

This photograph is of R. L. Rasmussen's Southwest Michigan booth at the Great Lakes Antique Mall in Coloma. His three books about Paw Paw Lake, Little Paw Paw Lake, and Deer Forest have evolved into a second career of becoming an author and southwest Michigan historian. At his booth or Web site, he has over 50 books and hundreds of postcard reproductions of Berrien, Cass, and Van Buren Counties. He also has copies of old plat maps, framed maps and pictures, and other memorabilia. In fact, Rasmussen has the largest selection in the world of nonfiction, in-print books for sale about southwest Michigan. His mailing address is Southwest Michigan Store, P.O. Box 916, Coloma, Michigan 49038.

The Jerdon Real Estate office is located near Indian Lake and Sister Lakes just west of Dowagiac along Highway M-62. The firm was established in 1950 by the late Floyd Jerdon Sr. (1906–1966). The firm is now in its third generation specializing in lake property and serving some 100 inland lakes in southwest Michigan. The variety of lakes available includes smaller, quiet, and very scenic lakes to full recreation lakes in Cass County, the south two-thirds of Van Buren County, and the western portion of St. Joseph County. The office is located within 100 miles of Chicago, where the firm cultivates its lake buyers along with other markets in northern Indiana. Floyd Jerdon Jr. and Thomas F. Jerdon presently operate the family-owned business. Their address is 32502 M-62 West, Dowagiac, Michigan 49047.

BIBLIOGRAPHY

Arseneau, Steven, and Ann Thompson. *Dowagiac*. Charleston, SC: Arcadia Publishing, 2005.

Atlas of Van Buren County, Michigan 1873. Philadelphia: C.O. Titus, 1873.

Carney, James T., ed. *Berrien Centennial 1776–1976*. Berrien County, MI: Berrien County Bicentennial Commission, 1976.

Claspy, Everett. *The Dowagiac-Sister Lakes Resort Area and More About Its Potawatomi Indians*. Dowagiac, MI: 1970.

Clifton, James A. *The Pokagons, 1683–1983: Catholic Potawatomi Indians of the St. Joseph River Valley*. Lanham, MD: University Press of America, 1984.

Garrity, Nancy Roberts. *The History of Gregory Beach*. Jim McLamore, 1992.

History of Berrien and Van Buren Counties, Michigan. Philadelphia: D.W. Ensign and Company, 1880.

History of Cass County, Michigan: With Illustrations and Biographical Sketches. Chicago: Waterman, Watkins, and Company, 1882. Reprint, Lansing, MI: Inter-Collegiate Press Service, 1985.

Map of the Counties, Cass, Van Buren and Berrien, Michigan. Philadelphia: Greil, Harley, and Siverd, 1860. Reprint, Dowagiac, MI: Clark Equipment Company, 1983.

Portrait and Biographical Record of Berrien and Cass Counties, Michigan. Chicago: Biographical Publishing Company, 1893.

Romig, Walter. *Michigan Place Names*. Grosse Pointe, MI: 1972.

Schoetzow, Mae R. *Brief History of Cass County*. Marcellus, MI: Marcellus News, 1935.

Schultz, Robert E. *Twin City Trolleys, A History of Street Railways and Also Interurbans in Benton Harbor and St. Joseph, Michigan*. Las Vegas: 1984. Reprint, Berrien Springs, MI: Berrien County Historical Association, 2004.

Semark, Douglas L., ed. *History of Van Buren County, Michigan*. Hartford, MI: Van Buren Historical Society, 1983

Standard Atlas of Cass County, Michigan, 1914. Chicago: Gel. A. Ogle and Company, 1914.